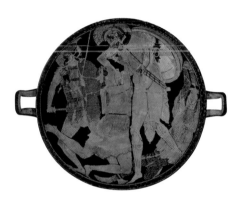

greek Art

MICHAEL SIEBLER
NORBERT WOLF (ED.)

TASCHEN

HONG KONG KÖLN LONDON LOS ANGELES MADRID PARIS TOKYO

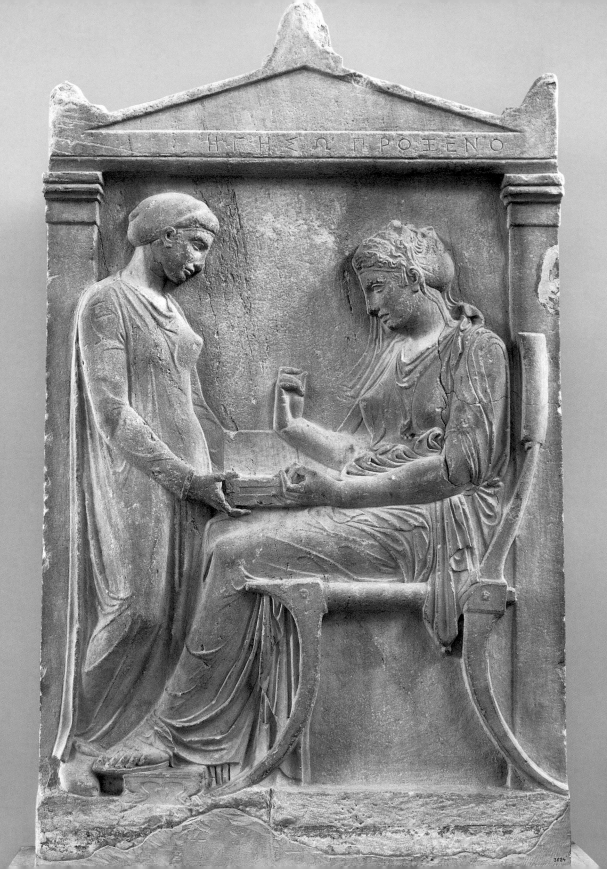

contents

The Beginnings of western culture

An ancient success story

It took around three centuries. Then, in the 8th century BCE the time finally came: unmistakably, Greece once more started playing a role among the civilizations around the Mediterranean. This relatively small, mountainous, and not particularly fertile country with its numerous islands had lost this status after the decline of the Mycenaean palace culture that had lasted from around 1700 to 1050 BCE. At that time the lords of the castles of, say, Mycenae, Tiryns, Pylos, or Thebes set the power-political tone in the mother country and made life difficult for some of their neighbours in the East, such as for example for the Hittite kings. With the end of this culture most contacts to the Mediterranean world also ended and many achievements were lost, such as knowledge of writing (Linear B).

The renewed emergence could not be overlooked. It was the beginning of a long success story, at the end of which Greek culture and art not only became the model for the Roman Empire that was seeking to become a world power, but also laid the foundations of our western-European culture – strictly speaking, then, this success story has not yet come to an end. Thus the Greek philosophers asked questions that still occupy us today. Architects designed towns and built temples whose special features can still fascinate planners and build-ers today, be it the monumental open squares, or the column used as a supporting or dividing element. Democracy is a form of government that developed within the walls of Athens and it was mainly Greek artists who created the human image in art. However: close as the Greeks are to us – they are also distant from us. Every generation must form its own image of Greek art and culture.

A lot had to happen before all these achievements were able to see the light of day: in the vacuum that existed after the decline of the Mycenaean palaces the remaining population and the tribes that had recently immigrated into Greece came to terms with each other. At the same time new ruling classes were arising – alongside the priesthood particularly the future aristocratic caste. In some areas close to the coast and in the east of the country, such as in Eretria on Euboea or in Attica, some of the old aristocratic families were able to hang on, not having even cut off their contacts to their eastern neighbours even in the dark times. And these contacts to the Phoenicians and the Egyptians were important for the greatly expanding trade in Greece in the 8th century BCE, because the luxury goods that the rising aristocratic class desired came from the Orient. The local craftsmen also recognized this new market for valuable goods of course. They were able to copy the foreign artworks and methods of production or change them as they saw fit and offer them to their customers and

776 — Start of the official victor lists of Olympia; Koroibos from Elis won the stadion race
753 — Marcus Terentius Varro, an author of the 2nd/1st century BCE, dated the founding of Rome to this year

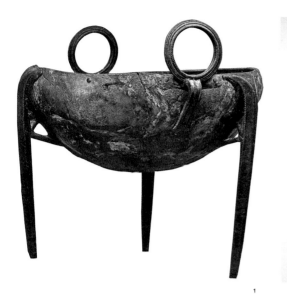

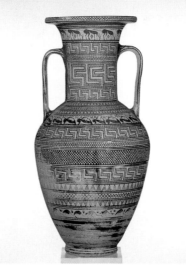

1. TRIPOD CAULDRON
early 9th century BCE, bronze,
height app. 65 cm,
handle diameter 16 cm
Olympia, Museum

2. DIPYLON MASTER
Attic necked amphora,
c. 760 BCE, clay, height 51 cm
Munich, Staatliche Antiken-
sammlungen und Glyptothek

masters, and even create their own works: these were the first steps towards the development of a genuinely Greek style.

The Greeks undertook the last and decisive step back onto the stage of events with the founding of numerous colonies in the western and eastern Mediterranean and on the shores of the Black Sea. They were mainly the result of overpopulation in their prospering home country. There will have been several occasions where the earlier and successful establishment of a trading post was the deciding factor why colonists founded a new settlement at a given location. Thus it must have been the case that numerous neighbours in the Mediterranean not only knew the Greeks but must have also had friendly and hostile encounters with them, conducted profitable trade with them as well as fierce fights for land-ownership.

The Geometric Era

In the inventory of the art of these years we come across three forms of vessel. We cannot imagine the Greek art of the following centuries without them. First of all, there is the tripod, a cauldron made of metal — usually of bronze — with three feet and two round handles (ill. p. 7).

It was initially meant for heating food over the fire. The cauldron could be taken off the fire with the help of a rod that was pushed through the handles. The tripod soon advanced to a highly valued object. These richly decorated metal artworks were found in the treasure chambers of kings and aristocrats as well as in temples, where they proclaimed both the wealth and the gratitude of the person making the offering to the deity. The objects, whose handles were decorated with small and slender warrior depictions and rich ornaments on the feet, were naturally no longer meant for everyday use, particularly since the dimensions became larger and larger. Later, tripods became desirable prizes for poetry competitions, a habit that was still customary in Roman times.

The two other forms are the amphora and the krater (ill. p. 7, 8). These were containers in which provisions could be stored or transported, or in which the strong Greek wine was watered down before it was drunk. The dimensional development of kraters and amphorae proceeded in the opposite direction: away from the monumental container that was set up on the graves of rich, deceased people and towards user-friendly sizes. If one looks at the clay containers of the 8th century BCE it quickly becomes clear why this early period of Greek art is called the "geometric era" by scholars. Besides the friezes of foraging game or birds, it is the geometric ornaments that are particu-

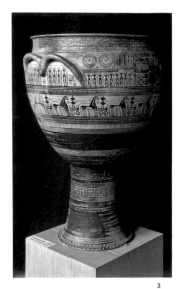

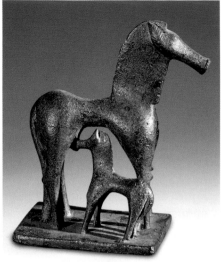

3. KRATER WITH PROTHESIS AND EKPHORA
c. 750/40 BCE, clay, height 1.23 m
Athens, National Archaeological Museum

4. MARE AND FOAL
8th century BCE, bronze
Athens, National Archaeologial Museum

3

4

larly striking: triangles, rhombi, chequerboard patterns, and the typically Greek ornament, the meander, in many variations (ill. p. 8). The animal friezes were clearly taken over from the orient, whereas the geometric ornaments speak of a definitely Greek language of forms – and this was also developed in the depiction of human beings. This form of the image of the human being during the geometric time may appear ambivalent these days: on the one hand one could call these figures simple, awkward "stick figures", on the other hand they may be considered positively modern. In any case, the Greek artists of the time did not understand the body as an organic whole, but as the sum of its parts that were in turn represented in their characteristic view; this is for example clearly visible at the connecting points between the frontally depicted chest and the lower body turned to the side. This "differential view" underlined the significance of a strong chest and faster, mobile legs. These were vitally important qualities for an aristocratic warrior to have, because those who did not possess them were at risk of being the weaker party in the deadly duels. The world of the nobility, mainly shaped by war and seafaring, was often a subject of the performing arts in the late 8th century BCE. – in those years when Homer recorded the Greek national epic in writing: the "Iliad" "sings of the wrath of Achilles" the hero during the ten-year Trojan War. The Greeks had taken over the alphabet from the Phoenicians.

Just as in poetry, life-and-death struggle was also a motif of the visual arts. In stories about the farewell of a deceased person, one can also recognize parallels between epics and contemporary painting. Accordingly, the great grave krater in Athens (ill. p. 8) shows how the deceased was mourned and lamented by relatives, friends, and servants as the body lay on the bier – the "prothesis". This was followed by the transport to the grave – the "ekphora". An escort of chariots and warriors could accompany the hero on his last trip.

The Path to the Archaic Human Image

The realization of the above-mentioned characteristics for the human image in the late 8th century BCE is very well illustrated in the example of a small sculpture, an ivory figurine from Athens. The modelling of the face with the distinctive eyes does not conceal the oriental models. However, the ivory carver did translate the latter's fuller and more flowing bodies into a personal artistic language, which can be seen at the triangular chest, the narrow waist, and the strong legs. And of course the meander on the head-dress of a naked woman particularly leads one to suppose its creation in a Greek workshop.

16 March 597 — Conquest of Jerusalem by Nebuchadnezzar of Babylon
595 — The renewal of Athens' laws by Solon

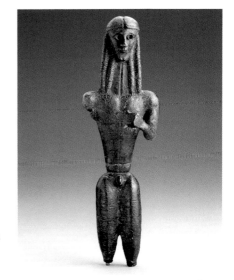

**5. STATUETTE, SO-CALLED
MANTIKLOS APOLLO FROM THEBES**
early 7th century BCE, bronze,
height 20.3 cm
Boston, Museum of Fine Arts

5

An important link in the history of Greece's visual arts between the geometric era (900 – 700 BCE) and the following archaic era (700 – 490/80 BCE) is a small bronze figurine that seems positively modern in its formal reduction (ill. p. 9). The purpose of this small artwork is engraved on the front of the thighs. A man named Mantiklos had dedicated it to the god Apollo from the tenth part of a win (a standard amount amongst the Greeks) together with the forthright demand that Apollo should now fulfil a wish for him, too. The understanding of "do ut des" – I give in order that thou givest – between deity and human being is thus on file for the early 7th century BCE.

The *Mantiklos Apollo* demonstrates in rudimentary fashion a new vision of human form. For the Greeks it was ultimately the central subject of the visual arts and thereby became a carrier and deliverer of values and norms of society, an example of the search for the exemplary human being – for his qualities and social standing. In every century the depiction of the human being in Greek art was the mirror image of how the Greeks saw themselves or rather how they wanted to be – and that of course entailed transition and change in the forms of representation, i.e. stylistic development.

Whether the bronze figurine was meant to represent Mantiklos or Apollo cannot be said for certain; the bent left arm could have held a bow or an arrow, which would speak for it being Apollo. He probably wore a helmet on his head, as is suggested by the hole in his forehead; the eyes were of a different material. The broad chest, narrow waist and strong thighs did still belong to the formal repertoire of geometric art, but the limbs have now become closely connected to each other, they no longer appear simply pieced together. Thus, the head is tightly fused with the body through the long hair and the over-long neck. Despite the small format the *Mantiklos Apollo* it appears to be almost monumental.

In this way he can be understood, so to speak, as a forerunner of the monumental stone sculptures that developed in the 7th century BCE, at the same time that architecture started making use of stone in construction, which made monumental temples and other buildings possible, such as the Temple of Hera on the island of Samos or the Temple of Artemis in Ephesus. Without a doubt the archetypes of archaic sculpture are the "kouros" and the "kore", the depiction, respectively, of a naked young man and a sumptuously-clad girl or young woman. These life-sized, sometimes larger than life-sized statues could be votive offerings in temples or could be set up on graves. They definitely represent the social ideals that were cultivated by the aristocratic circles of the time, because only those who had sufficient financial means were able to commission such statues. The long, groomed hair that we already see on the *Mantiklos Apollo* was, so to speak, the

566 — First Panathenaic Games in Athens in honour of the city's patron goddess Athenec
550 — Introduction of Athenian coinage **539 — Cyrus the Great conquers Babylon and turns Persia into a world power**

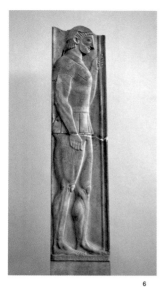

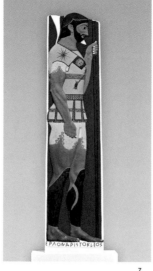

6

7

6. ARISTOKLEOS

Funerary Stele of Aristion
c. 510 BCE, marble, height 2.40 m
Athens, National Archaeological Museum

7. ARISTOKLEOS

Funerary Stele of Aristion
Reconstruction of its colours
Munich, Stiftung Archäologie

8. SOSIAS PAINTER

Achilleus bandages his friend Patroclus
Attical drinking bowl, c. 500 BCE
Berlin, Staatliche Museen zu Berlin – Stiftung
Preussischer Kulturbesitz, Antikensammlung

9. THE POETS SAPPHO AND ALCAEUS

c. 470 BCE, clay, height 52.5 cm
Munich, Staatliche Antikensammlungen und
Glyptothek

identification and privilege of the rich and powerful. Only members of this upper class were able to afford a lifestyle with elaborate hair and body care – and that is clearly demonstrated by the "kouroi". The peasant had to till his land to feed his family; there was no time and definitely no money for these kinds of creature comforts. In addition the naked, well-formed, fit bodies signal the physical strength and flexibility of the portrayed – never mind if he actually possessed these qualities or not, because the point was an ideal not a realistic appearance. The models for the "kouroi" are easy to name. They were the typical statues of Egypt with the left leg put forward, a loin cloth, and an obligatory back pillar. However, the Greek sculptors chose to do without the item of clothing and the pillar. Thus, the "kouros" stands freely on his feet and reaches far out into space – that was a uniquely Greek invention.

Nudity was the ideal for men, but for women the opposite was the case. Here, it was the precious clothing that enveloped the beautiful body signalled membership of the upper class. What is striking with the "kouroi" and the "korai" are their typical smiles. These "archaic smiles" must surely have had the same meaning for the Greeks as laughing does for us – signalling delight and happiness. It could also be understood as an expression of vitality, because a dead human being can no longer smile. If one considers that these sculptures were originally coloured, the radiant glory of such collections of men and girl statues in temples and other places must have been overwhelming (for more information on polychromy, see p. 23ff.). The grave stele of Aristion imparts a very good impression of how painted ancient sculptures may have looked originally; it is an "ergon Aristokleos", a work of the sculptor Aristokleos, as is carved beneath the deceased's foot (ill. p. 10). The reconstruction of the polychrome setting provides our visual expectations of ancient sculpture with quite a few surprises. Yet it is only the newly restored coloured setting that shows the entire finesse of the ornamentation on the armour, be it the lion's head, the bundle of rays, or the meander patterns. It also restores to Aristion his face with its alert eye and accentuates the strong body's muscles and tendons.

Suddenly, when one looks into the interior image on a drinking bowl (ill. p. 11), one recognizes the uncanny proximity of the colourfully reconstructed sculpture to thematically similar representations on Greek vessels. It is not just the shapes of the armour of the two depicted heroes – Achilles is bandaging his wounded friend Patroclus – that resemble each other, but also their detailed decoration, which can be clearly seen at the meander on Patroclus' coat of armour. The picture in the bowl portrays an episode from the Trojan War, i.e. from the mythical world of the heroes and gods.

534 — The Greek poet Thespis performs the first tragedy in Athens, allegedly from a cart (Thespis cart)
c. 530 — The Greeks found Paestum in Campania **525 — The Persian king Cambyses II conquers Egypt**

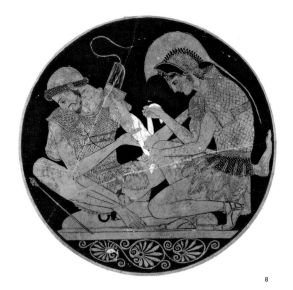

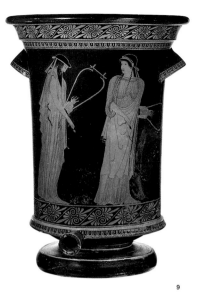

8

9

Pottery as an image medium

Like no other medium of ancient Greek art, pottery was uniquely suited for the dissemination of images and picture stories. Thousands of these artworks made of fired and painted clay have survived, most of them in graves where they were meant as burial objects for the deceased. Today one generally speaks of "Greek vases". This term can be misleading, because the containers with their many different shapes were of course not meant as vases for flowers, but had quite different functions. Thus, the three-handled hydria was used for fetching water, the krater was used for the mixing of water and wine, the kylix (bowl) or the kantharos was meant for drinking wine and the bottle-like lekythos was used for storing oil or perfume.

The explanation for the given collective term is simple: since the early discoveries of Greek pottery were found in the Etruscan necropolises in Italy they were named after the Italian word for vessel or pot, i.e. "vaso" (plural "vasi"). The Etruscans were enthusiastic fans of Greek vases, whose expressive and harmonious balance between form and image fields with figural or ornamental decoration can still inspire today.

Just as in other artistic genres, Athens also achieved a dominant market position in the field of pottery. Regular factories arose in the Kerameikos, the potters' quarter of Athens. Pottery-workshop owners, who often had many painters working for them, supplied the national and international market with their goods. The historical and scholarly value of the containers cannot be overestimated, irrespective of the often high level of artistic ability, because the depictions do not just tell a story from the mythological world, they also illustrate everyday life in ancient Greece in a unique way: be it the world of the rich or that of the craftsmen, be it an animal sacrifice in a temple or an athletic wrestling match, be it a happy drunken carousal or a sad departure of a warrior from his family. In addition all these scenes and images show us things that were irretrievably lost or destroyed over the centuries or that we can only now find in written traditions. This includes preciously worked tables, chairs, and chests, as well as valuable and richly-embroidered items of clothing and also the interior decor of homes or the workshops of bronze casters. Yes, many a vessel even depicts famous statues of gods or simple reproductions of well-known paintings that are lost forever. The Greek vase painters even seem to have translated quotes or literary episodes into pictures on some vessels for declared connoisseurs. Easier to recognize, also because of inscriptions, were the representations of the great Greek poetic duo, the lyricists Sappho and Alcaeus, on a wine container with a spout (ill. p. 11). Such a container was of course perfectly suited for a carousal

c. 523 – Death of Polycrates, tyrant of Samos
of Tarquinius Superbus; consecration of the Temple of Jupiter on the Capitoline Hill in Rome

509 — Founding of the Roman republic after the overthrow

11

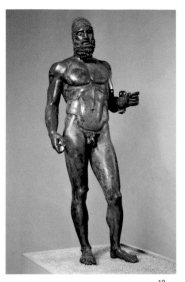
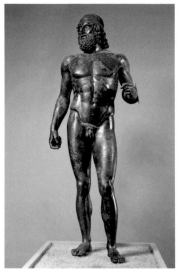

10 11

"The bronze together with art created beauty (referring to the orpheus statue), where the music of the soul was indicated by the magnificence of the body."

Callistratus, Statuarum descriptiones 7, I

at which a guest or two may have recited works of the two poets of the late 7th and early 6th centuries BCE.

A look at this wine container, called "kalathos", shows that the representation and thus the understanding of the human being had fundamentally changed in the 5th century BCE. There no longer was an austere frontal representation with close-lying arms let alone the almost graphic-abstract addition of individual body parts to form a whole, as was customary during the geometric era. No, at the turn of the 6th to the 5th century BCE, the visual arts had undergone significant changes whose effects reach right into the present. This new human image in Greek art was unthinkable without the fundamental changes in society, politics, and intellectual culture. A possibly comparable comprehensively revolutionary change in art and culture was the later transition from the Middle Ages to the Renaissance, when Antiquity advanced to a valid model in word and image and influenced all areas of life.

The Greek classical period: at the zenith of art and culture

To this day the 5th century BCE is considered the century of the "Classical Period" – the climax of all the artistic and cultural works in Greek Antiquity. Among the initiators of this period qualification was the archaeologist Johann Joachim Winckelmann (1717–1768) who became a founder of scholarly driven art history particularly with his "History of the Art of Antiquity".

Today it is no longer possible to grant the Greek classical period an unlimited claim to normative validity over all the periods of time, but one thing is certain: the Greeks of the 5th century BCE and particularly the Athenians, who played a special role anyway, were aware that they were living in a special time – and with good reason. Many things happened during those years: the end of tyrannical rule in Athens around 510 BCE and the introduction of democracy based on the reforms of Cleisthenes (508/07 BCE); the fight for freedom against the Persians with the decisive victories at Marathon (490 BCE), Salamis (480 BCE), and Plataea (479 BCE). This period also marked the golden age of Attic tragedy with Aeschylus (525–456 BCE), Sophocles (c. 497–405 BCE) and Euripides (480–406 BCE). In addition there was comedy, with Aristophanes (c. 455–388 BCE), and the beginning of the recording of history with Herodotus (c 484–430 BCE) and Thucydides (c. 460–400 BCE). Finally, with Socrates (c. 470–399 BCE), one of the most influential of all philosophers entered the stage (ill. p. 17), while the rhetorician Gorgias (c. 485–380 BCE) perfected the speech as a suitable method of persuasion in po-

508/507 — Cleisthenes' reforms in Athens make Athenian democracy possible
494 — The Persians conquer Miletus and put down the rebellion of the Greek-Ionian cities in Asia Minor

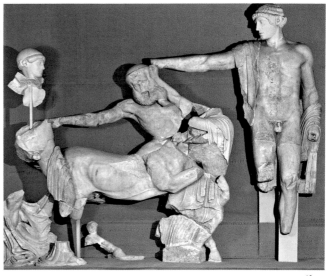

10. SO-CALLED RIACE WARRIOR B
c. 430/20 BCE, bronze, height 1.97 m
Reggio/Calabria, Museo Nazionale
di Reggio Calabria

11. SO-CALLED RIACE WARRIOR A
c. 460 BCE, bronze, height 1.98 m
Reggio/Calabria, Museo Nazionale
di Reggio Calabria

**12. STATUE OF APOLLO FROM
THE WEST PEDIMENT OF THE
TEMPLE OF ZEUS IN OLYMPIA**
c. 470/60 BCE, marble, height 3.15 m
Olympia, Museum

12

litics. However, the Peloponnesian War (431–404 BCE) was also one of the fateful events of this century, during which the two dominant powers Athens and Sparta fought each other in a merciless fraternal war together with their respective allies; at the end Athens was defeated – the democracy had lost. Thus it was no wonder that much changed in the lives of the Greeks during those dramatic decades.

The two famous bronze statues that were discovered in the sea off Riace in Calabria in 1972 (ill. p. 12) document very well the revolutionary newness of the art of that time: it is the distinction between supporting leg and free leg, between load and no load, the balancing of opposing movements of arms and legs, as well as the attention paid to flexed and relaxed muscles that are bound to occur in a natural representation of a human organism in a particular position. For us today this is self-evident – but this method of representation, known as "contrapost" or "ponderation" was invented in the 5th century BCE by Greek artists – and their laws formed the foundation of European art right into the early modern period. The Greeks did not just associate the realization of the aesthetic demands of the age with the artistically successful representation of a human being, rather they were convinced that they could thereby also depict and bring across ideal values: together with the perfection of the immaculate body, the perfection of the spirit, thoughts and actions. These relations, realized in

practice, were also discussed in theory. An example of this is the sculptor Polycleitus with his treatise "Kanon".

There is another reason why the accidental discovery of the two bronze statues is of great significance – they may have been representations of heroes. In any case they are Greek originals of high quality such as are only rarely found in the surviving stock of classical artefacts. It must not be forgotten that most of the works of famous artists are lost. Their appearance has only come down to us in copies that were produced in Roman times (from about the 2nd century BCE to the 2nd century CE) for the wealthy and powerful of the Empire, mainly for the decoration of palaces, villas, and gardens. Thus today we are particularly familiar with works from the classical period, sometimes there are several copies – be it faithful copies of a whole statue or of just the replication of the head or rather of the portrait of a meritorious politician (ill. p. 77), a philosopher (ill. p. 17), or of a poet who had been honoured with a statue in his likeness.

The naked athletic body of the *Doryphoros* or "javelin-bearer" (ill. p. 67) created by the sculptor Polycleitus in c. 440 BCE, which already in Antiquity was understood as an exemplary representation, has only survived in the form of copies from Roman times, albeit around seventy of them – an indication of the particular estimation of this statue even in a later age. What is also noticeable is that the copies were

490 — Under the leadership of Miltiades the Younger, the Greeks are victorious against the Persian army at Marathon

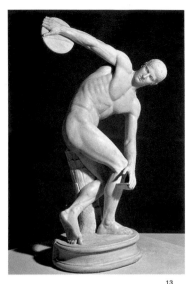

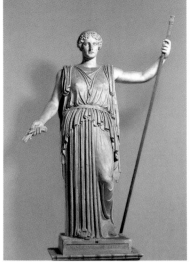

13. AFTER MYRON

<u>Discus thrower, so-called Lancelotti</u>
<u>Diskobolus</u>
Roman copy after a bronze original
c. 450 BCE, marble, height 1.55 m
Rome, Museo Nazionale Romano
(Museo delle Terme)

14. STATUE OF A DEITY
(augmented into Demeter)
Copy after a Greek original from the
5th century BCE
Rome, Vatican Museums, Museo
Pio-Clementino

13 14

nearly all made of marble or another stone instead of in the same material as the lost original — namely bronze. Thus one has to constantly remind oneself that without these copies from Roman times our rich body of knowledge of masterpieces from the Classical Period, but also from other centuries, would not have been possible and thus a history of Greek sculpture would have been unthinkable.

One Greek original that *was* made of marble on the other hand is the over life-sized statue of *Apollo* from the west pediment of the Temple of Zeus in Olympia (ill. p. 13). It depicts the god in a formal language that follows a new understanding of the human being. Calm and serenely superior, he stood in the middle of the pediment, a masterpiece of the early-Classical "Austere Style". With a majestic gesture, he appears to be putting an end to the raging battle between the Lapiths and the Centaurs at the wedding of the Lapith king Pirithous. To this day the sculptures of the Temple of Zeus in their entirety are the most impressive and complete ensemble of early-Classical sculpture from the years around 470/60 BCE. However, it is not known who sculpted them. The anonymity of many sculptors or painters of Antiquity accompanies every journey through Greek art history. This is also true of the painter of the *Penthesilea bowl* (ill. p. 1), a masterpiece of Attic vase art. It portrays the tragic moment in which Achilles killed the Amazon queen Penthesilea — and falls in love with her as

she is dying. Despite the murderous brutality of the hero at Troy it is a moving scene whose dramatic art is heightened by the composition of the picture, whose protagonists appear to burst the confines of the bowl. On the left a speechless Greek observes the event, while on the right the corpse of a dead Amazon fills out the remaining surface of the bowl. While Achilles is only wearing his weapons and a cloak — so he is really appearing in typical heroic nudity — the dead Amazon is dressed like an oriental warrior, with tight-fitting, boldly patterned trousers and an equally richly-decorated undergarment over which she is wearing a thin tunic reminiscent of the Greek chiton. Apart from the mythical subject of the scene this Amazonomachy — or battle between Greeks and Amazons, the Oriental cavalrywomen — could also be understood as a metaphor for the enmity between Greeks and Persians, between the Hellenistic peoples and barbarians. The subject of Amazonomachy can be seen again and again in Greek art, whether on vase paintings or in the image programmes of numerous Greek temples, for example on the Parthenon in Athens.

Alongside unknown artists that have created masterpieces, there are also those whose names are known and whose famous works have been identified amongst the surviving stock of artefacts. Amongst these is surely the sculptor Myron, a contemporary of the master of the *Penthesilea bowl*. Two of his works are known: a dis-

480 — The battle at the pass of Thermopylae, when the Spartan Leonidas I and his 300 Spartiates sacrifice themselves, is lost by the Greeks, but the naval battle at Salamis planned by Themistocles results in the defeat of the Persian fleet 472 — Performance of Aeschylus'

14

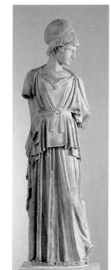

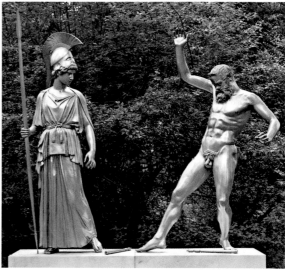

15. AFTER MYRON

Athene
Roman copy after a bronze original
c. 450 BCE, marble, height 1.73 m
Frankfurt on the Main, Liebieghaus –
Skulpturensammlung

**16. MODERN BRONZE RECON-
STRUCTION OF THE GROUP WITH
ATHENE AND MARSYAS BY MYRON**
Frankfurt on the Main, Liebieghaus –
Skulpturensammlung

15

16

cus-thrower, the *Diskobolos* (ill. p. 14) and a double group consisting of the goddess Athene and the satyr Marsyas (ill. p. 15). The statue of the *Diskobolos* was certainly a votive offering of an athlete who was victorious in this genuinely Greek athletic discipline. Whether the bronze original was located in Olympia, Delphi, or somewhere else is not known. The artist did not choose the moment in which the athlete stepped up for his throw or when he was just about to catapult his discus, rather he chose a short moment when the athlete was reaching out. It is exactly this moment frozen in an image that contains both the before and the after – that is what gives the representation its incredible suspense. It is this twisting of the body, this turning of the head, this momentum of the movement that attest to the proverbial vividness of Myron's statues. Not for nothing did even the ancients consider the *Diskobolos* an example of an artful construction of a complicated composition. Thus he was cited by Quintilian (c. 35 CE – end of the 1st century CE) in the latter's "Institutio oratoria" (The training of the orator) and used as a comparison when Quintilian was pleading for innovations in rhetoric – for movement that provided variety just as it did in the visual arts. This is a significant example of the close relationship between the visual arts and literature.

The group containing Athene and the satyr Marsyas, whose bronze original was located on the Acropolis in Athens, is also a mas-

terpiece by Myron, whose name was cited in the same breath as those of his famous fellow-sculptors Phidias and Polycleitus. Pliny the Elder mentioned it, as did Pausanias. It was also represented on coins and vases – a definite indication of its fame. The *Athene-Marsyas* group is an interesting and typical example of a commissioned artwork in Classical times, created not for its own sake, but rather in reaction to a specific occasion: the subject is a story from Greek mythology. Athene, who had invented flute-playing, disgustedly threw away the double flute when, seeing her reflection in water, she saw how her air-filled cheeks disfigured her face. Just at that moment Marsyas appeared on the scene and took the instrument for himself. Disregarding the goddess's warning he challenged Apollo to a competition and paid for this hubris with his life.

Myron chose a certain moment of the event where Athene looked back as she was walking away, while the satyr, almost incredulously sensing his chance, is just about to grasp for the flute. The design brings across movement and tension in Marsyas and calm, almost absorption even, in Athene. Though one first thinks of a monument for a musical competition when one sees this commissioned work, scholars now suspect a more political background, for example another metaphor for the enmity with the Persians, who were consequently represented by the wild Marsyas. Or it may symbolize the contempt

"The Persians" 447 — Start of the construction of the Parthenon on the Acropolis in Athens c. 432/31 — Phidias is accused
by the Athenians of embezzling ivory or gold for the *Athene Parthenos* and of blasphemy and dies, possibly in prison

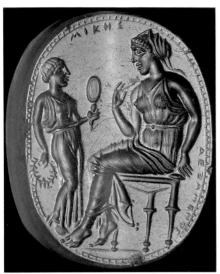

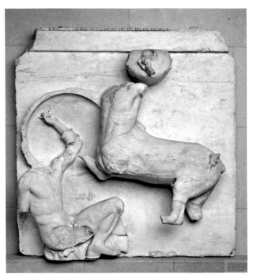

17

18

which Athens had for its neighbours to the north-west in the fertile landscape within Boeotia, where the Athenians had lost their political influence during those years. In this case Marsyas would be the personification of what were, in the eyes of the losers, uncultured peasants – a questionable act of defiance on the part of an arrogant, defeated party. Unfortunately no interpretation of this matter can be called correct for certain.

Perhaps it is difficult these days to find an artistic answer to a concrete historical event, such as a victorious campaign or the honouring of a deserving poet or politician, in such mythical groups or supposedly simply designed statues of gods. However, such allusions in mythical guise were customary and were also understood. Thus the meaningful monument had been part of the everyday lives of Greeks particularly since the 5th century BCE and often enough a now lost inscription might have removed the last doubts about why a statue of a god was set up at this specific location. We are also familiar from later centuries with this method of interpretation, namely to find a further and decisive level of meaning behind an insignificant-seeming image. Many an artist understood how to integrate into a work subtle power-political messages that were not apparent on the surface but easily decipherable to those who had knowledge of such significant subtleties.

Athens' splendour

This tension between power-political greed and great artistic achievement was perhaps nowhere so concretely expressed nor appeared so apparent to visitors in classical times as in Athens. The introduction of democracy certainly contributed to this special position and it also left its mark on the societal value systems of other city states without democratic constitutions.

Through her leadership of the Delian League, which was formed as a strategic alliance against the Persians shortly after the Persian Wars of 478/77 BCE, Athens was able to maintain and extend its dominance alongside Sparta in the concert of Greek city states. A concentration of the financial means for the equipment and maintenance of the Athenian fleet, in addition to the obligatory state treasury, made possible the realization of great building projects and numerous public and private foundations. The crowning moment of this building activity and the magnificent inaugurations was surely the extension of the Acropolis. Two names are inextricably connected to this undertaking, significantly that of a politician and that of a great artist: Pericles (ill. p. 77) who led the city's political fortunes from 461 to his death in 429 BCE, and Phidias, who was one of Pericles' closest advisers and who, besides the production of his own art works, was

431 — Start of the Peloponnesian War 429 — Death of Pericles
404 — Athens capitulates in the Peloponnesian War

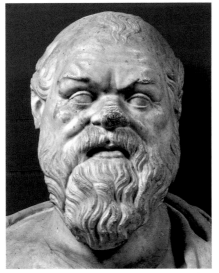

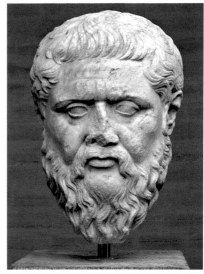

17. DEXAMENOS OF CHIOS

<u>Woman at her Toilet</u>
Gem, c. 450/25 BCE, chalcedony, height 2.2 cm
Cambridge, The Fitzwilliam Museum

**18. CENTAUROMACHY,
SOUTH METOPE 4 OF THE PARTHENON**
c. 440 BCE, marble, height 1.34 m
London, The British Museum

19. PORTRAIT OF SOCRATES
Roman copy after an original c. 370 BCE, marble
Rome, Vatican Museum, Museo Pio-Clementino

20. PORTRAIT OF PLATO
Roman copy after a bronze original c. 345 BCE,
marble, height 36 cm
Munich, Staatliche Antikensammlungen und
Glyptothek

19

20

also responsible for the organization and execution of the great building projects.

His most famous work, besides the cult statue of Zeus in Olympia (ill. p. 78, 79), is the gold and ivory image of *Athene Parthenos* (ill. p. 73), which was located in the temple of the goddess on the Acropolis, namely the Parthenon, completed in 432 BCE. This new Periclean temple built for the city's patron goddess was not just a peak of classical art, but also of course of political self-presentation, which quite firmly made use of the visual arts as a medium during these years. Athens' splendour and glory since mythical days gone by were affirmed in the sculptures on the building, in the two pediments as well as on the frieze (ill. p. 69, 71). The images on the metopes also celebrated Greek superiority over the barbarians – i.e. over the other peoples who did not have Greek culture – and with that they particularly glorified the grandeur of an Athens that considered herself, after all, the school of Greece and the world. The stories were famous ones from the world of mythology: an Amazonomachy on the west side, the battle between gods and giants on the east, the fall of Troy on the north, and the battle between the Lapiths and the Centaurs on the south side (ill. p. 16); a subject that was already depicted in the west pediment of the Temple of Zeus in Olympia and could also be seen as a symbol of the victory of just Greek order over barbarian chaos.

Athens made this comprehensive claim more than ever in the first years of the Peloponnesian War (431–404 BCE), the great and fateful confrontation with Sparta and its allies over the supremacy in Greece. That the fields were ravaged by the enemies every year, that many villages were abandoned, and that the rural population barricaded itself behind the walls of Athens, added to which the great plague still raged in the first years of the war, claiming Pericles among its victims – none of these hardships and defeats are explicitly reflected in the artworks.

A motto like "life just goes on" seems just too simple: rather we cannot help believing that the politicians, with their magnificent official art demonstrating their own power, wanted to present a counterimage to reality. Its message was clear: everything was good, is good, and will be even better. Of course there were also voices that critically examined the events, thus for example the comedic poets, or the tragic poets with their dramas that certainly reacted to the current events in mythical disguise. We just need to recall Aristophanes' "Lysistratus" – the anti-war play that with good reason finds its way into theatrical repertoires time and again to this day. Amongst the philosophers, the Sophists, Socrates among them (ill. p. 17) also stirred up criticism of the existing circumstances with questions about human knowledge and about a way of life bound to ethical norms. They heralded a re-

399 — Socrates is put to death by poison **347 — Death of Plato**
343 — Aristotle becomes the tutor of the Macedonian prince Alexander, the future Alexander the Great

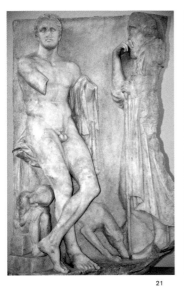

21

22

**21. TOMB OF A YOUTH FROM ILISSOS,
SO-CALLED ILISSOS-STELE**
c. 340/30 BCE, marble, height 1.68 m, width 1.07 m
Athens, National Archaeological Museum

22. FRAGMENT OF A GRAVE STELE
5th century BCE, marble
Athens, National Archaeological Museum

**23. GOBLET KRATER WITH BURLESQUE
SCENE**
c. 350 BCE, clay, height 37 cm
Berlin, Staatliche Museen zu Berlin – Stiftung
Preussischer Kulturbesitz, Antikensammlung

**24. PORTRAIT OF ALEXANDER
THE GREAT FROM THE SO-CALLED
ALEXANDER MOSAIC**
Roman copy of a monumental painting of the 4th
century BCE, mosaic, height 3.42 m, width 5.92 m
Naples, Museo Archeologico Nazionale

thinking that was then further developed by the students and followers of Socrates, particularly by Plato (427 – 347 BCE, ill. p. 17) and Aristotle (384 – 321 BCE, ill. p. 21).

The strengthening of the democracy and the experience of the defeat in the Peloponnesian War also changed the imagery in the art that was not meant primarily for the public sphere. Thus for example pictures from the world of the aristocracy and its ideals – in vase painting, say – were slowly pushed out and replaced with subjects from family life and private prosperity – perhaps an indication of the desire for the small pleasures in times of war and need. The gem-cutter Dexamenos from the island of Chios captured such a scene on a cameo (ill. p. 16). It portrays Mikes, the lady of the house, at her toilet; Dexamenos engraved his name and that of the woman on the edge. Mikes is sitting on a stool and is touching the hem of her gown. She is looking into a hand mirror that a small servant is holding up for her; in her other hand the girl is holding a wreath with which her mistress will adorn herself.

A visit to the theatre could also provide a small escape from the problems of everyday life and political reality – if they were showing farces and satyrs instead of tragedies. A scene from such a farce is depicted on a krater in Berlin (ill. p. 19). The boards that signify the world rise up above the columns. The actors are wearing tricots that are meant to simulate nudity, with padded buttocks and a big hose-shaped phallus. Even without knowledge of the piece the scene can be understood. Two men have carried a chest outside from the front door on the left and an old clamouring man is clinging on to it. Now they want to pull him off the lid that the old man is keeping locked with his body; evidently he wants to protect the treasures contained inside. This will be from one of those pieces where the miser will eventually lose out.

However, nobody was able to escape from the brutal reality of the war or from the incurable diseases. People constantly had to say farewell to their relatives and set up gravestones in remembrance. This was the case during the Geometric and Archaic periods just as much as during the Classical period. It was particularly the wars of the Greek city states between themselves that demanded their toll in blood every year. Nearly every family must have had to mourn fallen father, husbands, or sons.

The *Ilissos Stele* (ill. p. 18) a grave relief from Athens with nearly life-sized figures movingly shows the sorrow connected with such a loss. The deceased naked youth is leaning on a pillar that could be his tomb. Impassive towards the events taking place around him he seems to peer into the eyes of the beholder. A young boy, presumably a servant of the dead youth, is sitting asleep on the steps of the base,

338 — The Greeks are defeated by Philip II of Macedon at Chaeronea
336 — Philip II is assassinated and his son Alexander takes the throne

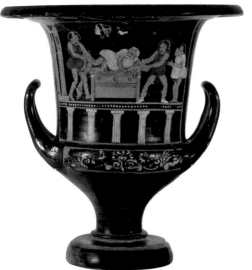

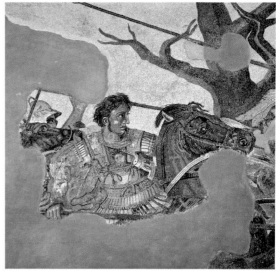

23

24

possibly an indication of the death. His dog and the throwing-stick hanging from his left arm mark the deceased as a hunter. The bearded father dressed in a cloak and leaning on a cane is looking meditatively on his son who died so young, his right hand lifted up to his chin. The expression of individual grief is often found on the tombs of these years, whether they were set up for men or for women. While they did still orient themselves by the traditional human images when it came to their depiction, now one can also recognize scenes and compositions that break with the customary conventions and allow stirrings of the soul as well as personal grief.

With her defeat in the Peloponnesian War, Athens naturally lost her claim to political leadership, although she did later rise to become a centre of Greek art and culture once more. However, Sparta was also unable to maintain her position of power in spite of her victory. The Bœotian League under the leadership of Thebes was a further opponent with power-political desires in the 4th century BCE. None of the three, however, managed to force the other two into submission.

Finally the person who was to put an end to the situation came down from the north: King Philip II of Macedon (ruled from 359 – 336 BCE) ended the independence of the Greek cities and city states once and for all with his victory in the battle of Chaeronea in central Greece in 338 BCE. His son Alexander III (356 – 323 BCE) suc-

ceeded him in 336 BCE. It was he who changed the ancient world like no one else before him, who conquered a world empire, and went down in history as Alexander the Great (ill. p. 19 and 81). His campaign into Asia Minor, Egypt, Persia and India created completely new conditions for politics, culture, art and social life. With Alexander the era that we call the "Hellenistic period" began. It lasted until the conquest of Alexandria in Egypt in 30 BCE by the Romans under the leadership of Octavian, the future emperor Augustus (63 BCE – 14 CE).

Hellenistic Art

After the early death of Alexander his successors, the Diadochi, divided the empire up between themselves and founded dynasties named after them: the Antigonid dynasty ruled over Macedonia, the Seleucids ruled over Syria, Mesopotamia, and the rest of the east. The Ptolemaic dynasty secured Egypt for itself. A few years later Attalus I (269 – 197 BCE) succeeded in installing the Attalid dynasty in Pergamon. Here a centre of artistic and literary culture arose that considered itself the heir of Athens' Classical past.

After Alexander the Great the imagery of Greek art lost its relative uniformity. During the course of the confrontations with the

333 — Battle of Issus, King Darius III of Persia flees, he dies in 330
10 June 323 — Alexander the Great dies in Babylon

331 — Founding of Alexandria in Egypt

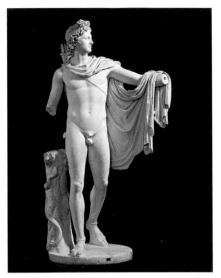

25

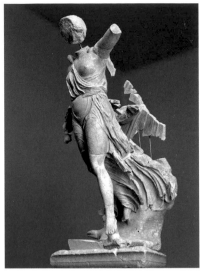

26

"ɪɴ ʜᴏᴍᴇʀ ... it is to be read every-where that the gods have a human body, a flesh that lances can spear, glowing red blood that flows, desires, moods, and appetites which are just like ours and to such an extent that heroes become the lovers of the goddesses and gods have children with mortals. ꜰʀᴏᴍ ᴍᴏᴜɴᴛ ᴏʟʏᴍᴘᴜs down to us there is no abyss, they come down from it and we climb up it and if they are super-ior to us it is only because they are spared death ..."

Hippolyte Taine, Philosophy of Art, 1882

oriental cultures and religions the formal and content-related con-ditions changed almost overnight. However, the establishment of a new ruling class also contributed to the change, since the rising mon-archies provided a reason for new models of self-representation. It is no wonder that the chronology of many an artwork of these centuries is not certain, because several artistic styles existed alongside each other in the different parts of the Diadochi realms. The portrait is a sig-nificant example for what was new in Hellenistic art. Here Alexander the Great set great standards with the ruler ideal that he embodied and that clearly distinguished itself from the Classical honour statues (ill. p. 81). His charisma was not represented by a bearded counte-nance characterized by calm facial features without striking physio-gnomic idiosyncrasies. The new world ruler presented himself as youthfully beardless, with an opulent head of curls that culminated in a curl brushed up steeply from his forehead, a style called "anastolé", which was probably meant to recall a lion's mane. The king's resolute gaze into the distance was emphasized by an equally resolute turn of the head to the right: a representation that embodied the ideal of the youthful, athletic hero.

Alexander's successors, all of them older men, were of course unable to present themselves as world conquerors bursting with youth. They kept the beardlessness coupled with an intense look. However,

the physiognomy had to bring across something different with its dy-namically animated facial expression: powerful presence and concern for the people in their care.

This ruler ideal is particularly clear in a portrait of a Hellenistic potentate that possibly depicts Attalus I of Pergamon (ruled 241–197 BCE), who had accepted the royal title after his victory over the Celts in around 240 BCE. The artist furnished the picture of the ruler with immense pathos, which worked because of the use of the formulas known since Alexander: the wide-open eyes with the gaze directed upwards into the distance, the resolute turn of the head, and the con-vex forehead with the raised eyebrows. A band in the hair was the sign of kingly dignity.

The change in ruler iconography was not without consequences for the images of gods and humans. One of the most famous divine images of the time of Alexander must surely be the *Apollo Belvedere* (ill. p. 20), which was praised as the artistic climax of Greek sculpture by Johann Joachim Winkelmann: "The statue of Apollo is the highest ideal of art amongst all the works of antiquity that managed to survive those times." The bronze original, which is generally accredited to the sculptor Leochares, possibly even stood in the newly constructed temple for Apollo Patroos in the Agora in Athens. In any case, the pur-poseful, dynamically animated stride of the youthfully radiant god

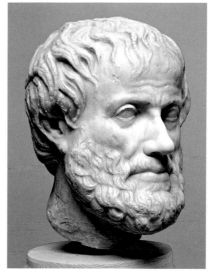
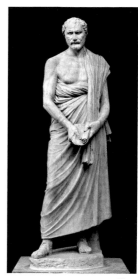

25. AFTER LEOCHARES
<u>Apollo Belvedere</u>
Roman copy after a bronze original
c. 320 BCE, marble, height 2.24 m
Rome, Vatican Museums

26. THE NIKE OF PAIONIOS
c. 420 BCE, marble, height 2.12 m
Olympia, Museum

27. PORTRAIT OF ARISTOTLE
Roman copy after a bronze original
c. 320 BCE, marble, height 29 cm
Vienna, Kunsthistorisches Museum

28. STATUE OF DEMOSTHENES
Roman copy after a bronze original dating
from 280 BCE, marble, height 1.92 m
Copenhagen, Ny Carlsberg Glyptotek

27

28

is unthinkable without the influence of contemporary likenesses of Alexander the Great.

The beardless Alexander served as the role model for the ruler iconography, but this was not true of other portraits, those of philosophers, poets, or politicians, for example. The portrait of Plato's pupil Aristotle (ill. p. 21) – he was Alexander's tutor – created shortly after his death depicts the philosopher in a manner typical for us: a well trimmed beard frames the face of a wise, older man who definitely looks like he has been hob-nobbing with the great names of the world and whose forehead wrinkles characterize him as a "thinker".

The statue of the Athenian politician Demosthenes (384 – 322 BCE) also takes a great step away from the Classical image ideal of a deserving citizen or statesman. The statue, erected in 280 BCE (ill. p. 21), honoured a man who, with his Philippic speeches, frantically defended democracy and thus the freedom of his home city of Athens against the father of Alexander the Great. The king of Macedon was a barbarian in his eyes. Demosthenes is standing with his arms crossed in front of his body, his demeanour seems composed – an impression strengthened by the extensive draping of his cloak. However, a look into his face shows the furrows and worry wrinkles, the deep-set eyes, and the tightly pressed mouth – overall it is the expression of someone who is despairing and resigned, of someone who has lost his

rhetorical battle against the politicians, a battle fought at the highest level. The statue is a typical example of a work of the early Hellenistic period, in what is called the "Attic simple style".

During the course of Alexander's conquests Greek culture spread over the entire Mediterranean region and further into modern-day Iran and into India. That of course changed the Greeks' view of their fellow human beings in other lands. It also drew attention to the losers at the edge of society who, unlike the citizens and the powerful could not live in the new cities like Alexandria in Egypt or Antioch in Asia Minor in more or less secure social conditions, let alone in luxury.

These new contacts with strangers and the new experiences with other cultures found their expression in visual art. While previously the ugly features of bodily decay of an old emaciated fisherman or the deformities and disabilities of hunchbacked beggars were at the most represented in caricature, there was now a matter-of-fact view of reality. A well-known masterpiece of this new "realism" is the statue of a drunken old woman (ill. p. 24). The haggard and wrinkled old woman is sitting on the ground, all skin and bones. This decay becomes apparent at her right shoulder, where her gown has slipped, revealing her emaciated body. She has thrown her head back. The big bottle in her lap, decorated with the ivy of the wine god Dionysus, explains her maudlin singing or babbling from an open mouth with teeth reduced to

215 — Carthage allies itself with Macedonia and Syracuse against Rome

212 — The Greek physicist and mathematician Archimedes dies during the conquest of Syracuse by the Romans

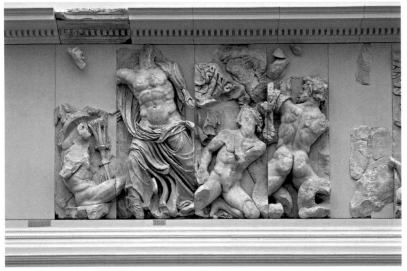

29. "ZEUS GROUP" OF THE GREAT FRIEZE OF THE PERGAMON ALTAR
180/164 BCE, marble, height 2.30 m
Berlin, Staatliche Museen zu Berlin – Stiftung Preussischer Kulturbesitz, Pergamonmuseum

30. STATUE OF LAOCOON
late 1st century BCE, or copy after an original dating from the mid-2nd century BCE, marble, height 1.84 m
Rome, Vatican Museums

stumps. Her intoxication allows her to escape the sad reality of her existence. The woman must have known happier times, though, as is suggested by her clothes – a better undergarment and a woollen cloak, as well as her (now lost) gold earrings. Her hair under the hood is also still carefully dressed. It is possible that she used to be a desired and rich hetaera (courtesan) who in old age was naturally no longer able to interest clients or generous lovers. It is unclear where the sculpture was located, perhaps in the garden of a rich citizen or in a public park. There she may have created a fitting contrast to the lofty statues of gods and beautiful human images, giving people a view of reality beyond their own front door, outside of the aloof sphere of great villas and palaces.

The Hellenistic artists broadened their repertoire to include ruthlessly realistic, masterful depictions of people who were enjoying the sunny side of life, but in a counter-move they also created works whose subjects they found in the sphere that transcended all earthly things – the sphere of mythology. Foremost among these masterpieces whose dramatic art and pathos keep their beholders in awe is the great frieze of the Altar of Zeus in Pergamon.

This 120-metre-long battle depiction that surrounds the base of the altar represents the battle of the Olympian gods with the giants for domination of the world. As so often in Greek art, the subject here was again a metaphor for an historical event: the victory of Eumenes II of Pergamum (197–159 BCE) over the Celts, or Galatians as they were called in Asia Minor. The sculptors, working from a complete plan, exhausted all the formal possibilities of Hellenistic sculpture. The pathos and the anatomy of pain can hardly be outdone. In the "Zeus group" (ill. p. 22) the father of the gods is throwing his death-bringing lightning at two giants who are desperately trying to defend themselves. One of them, already hit in the thigh, is sinking to the ground. The realism of the scenes is impressive, both when it comes to body composition as well as the detailed work on the weapons, the scales of the snakes' bodies, the torches, and the feathers of the wings.

It is even more surprising today that with a few exceptions Hellenistic art was not appreciated much by the Romans and was also not copied for that reason. The representatives of the new world empire, the Imperium Romanum, preferred to put marble copies of famous works of the Classical period in their villas and gardens. Often enough it was the originals stolen or looted from Greece that decorated the public squares and buildings in Rome. This judgement of taste is the reason why numerous copies from the 5th and 4th centuries BCE have come to light during excavations. This is why we are more familiar with the visual art of the Greek Classical period than with that of the Hellenistic period.

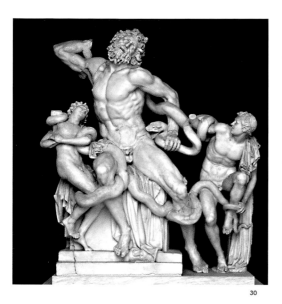

30

> "Just as the depth of the ocean is always calm, however much the surface may be raging, the expression in the figures of the Greeks, whatever their passion, displays a large and composed soul. This soul is written in Laocoon's face, and not just in the face, in the presence of intense suffering."

Johann Joachim Winckelmann, Thoughts on the Imitation of Greek Works in Painting and Sculpture, Dresden, 1755

Another masterpiece that raises dramatic realism to the extreme is the famous *Laocoon group* (ill. S. 23). The sculptors Polydorus, Athenodorus, and Agesander of Rhodes, depicted the gruesome end of the Trojan priest Laocoon and his two sons, who were killed by the snakes of Apollo. This was punishment for Laocoon's having warned the Trojans against bringing the Wooden Horse within the city walls, because, as he said, there was evil in its stomach. His crime, in the eyes of the gods, was to attempt to avert a decision they had already taken, namely the fall of Troy. As famous as this marble group is – discovered in Rome in 1506, it served Michelangelo as a model and inspiration for his figures on the ceiling fresco in the Sistine Chapel – the crucial questions are still unanswered: when was it created? And: is it an original or a copy of a bronze original? Here archaeology has not been able to throw light on the matter. The suggested dates go from the second half of the 2nd century BCE to the 1st century CE.

Especially such open questions like those surrounding the *Laocoon group* are a good example of how necessary further research in the field of Greek art is – to get new fascinating answers to exciting questions.

The colour of ancient artworks – new research on polychromy

In his "History of the Art of Antiquity", which appeared in 1764, Winckelmann made a judgement that was going to have considerable effects on art history: "Since it is white that reflects the most light, it consequently is more sensitive: hence a beautiful body will be the more beautiful the whiter it is." Thus the founder of art archaeology virtually defined the classical beauty ideal. He elevated the pure white marble to the status of aesthetic norm for the art of Classical Antiquity. This norm was considered the yardstick for art as such, and particularly for that of his own time, as the works of Antonio Canova (1757–1822) or Bertel Thorvaldsen (1768–1844) show. Even Michelangelo (1475–1564) had created his *David* from this purest and most valuable of materials a sculptor had at his disposal.

Even Winckelmann could not blindly ignore many a trace of colour on ancient sculptures, but the "barbaric custom of painting marble and stone" was and remained abhorrent to him. This view of things could be defended successfully for a long time by simply categorizing the coloration of ancient sculptures as an earlier, more primitive stylistic level or by labelling it without further ado as an Etruscan idiosyncrasy. However, not even Winckelmann's dictum was able

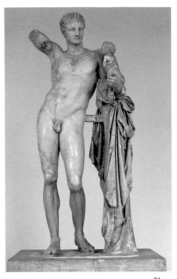

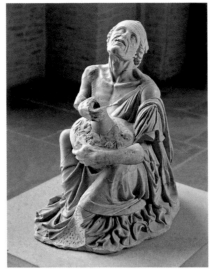

31. PRAXITELES
<u>Hermes and Dionysos</u>
c. 330 BCE, marble, height 2.15 m
Olympia, Museum

32. DRUNKEN OLD WOMAN
Roman copy after an original c. 200 BCE,
marble, height 92 cm
Munich, Staatliche Antikensammlungen und
Glyptothek

33. "PARIS" FROM THE GROUP OF AEGINIANS
Reconstruction of its colours
Munich, Stiftung Archäologie

31

32

to prevent the idealization of the bright white marble from being exposed as an illusion. Traces of colour on newly discovered artworks in Greece and Italy were all too obvious. Consequently there was an intensive concern with the question of the painting of ancient sculptures. Thus, in 1811 the excavators of the Temple of Aphaea on Aegina were already documenting the colour traces on the pediment sculptures (ill. p. 25 and 53) and on parts of the architecture.

The ensuing discussion on the polychrome nature of ancient sculpture developed into a sometimes heated debate that lasted until World War II. A group formed that proclaimed a middle way between the two extremes of "marble white" and "garish". Some favoured a di-chromatic look consisting of blue and red on a white background, because traces of these colours were often still visible on sculptures. Others put their faith in gold and white – a concept known from Rococo sculpture. Amongst the protagonists of these lively discussions were famous architects and classical scholars, such as the court archaeologist of King Ludwig I of Bavaria, Johann Martin von Wagner (1777–1858), the creator of the Dresden Opera House Gottfried Semper (1803–1879), and the future director of the Glyptothek in Munich, Adolf Furtwängler (1853–1907).

Today it seems incomprehensible that interest in polychromy not only faded, but was almost forgotten. In the scholarly discourse of art history and archaeology, in any case, it hardly continued to play a role worth mentioning. One of the decisive factors was the re-orientation of ideological-aesthetic discussions following the trauma into which Europe had been thrown by World War II. Particularly the post-war generation of archaeologists retreated into a formal-aesthetic approach. While the existence of polychromy was by no means denied, it was nonetheless pushed to the fringes of scholarly interest. Thus it is no wonder that our conception of the appearance of ancient sculptures and buildings continues to be shaped by marble-white monuments, as presented by museums all over the world.

The research done by the archaeologist Vinzenz Brinkmann from Munich, who has been devoting himself to examining polychromy for more than twenty years, is therefore all the more significant. His results can justifiably be called spectacular. He has examined hundreds of artworks from Greek and Roman times in all the great museums of the world – alone and with the help of other scholars, with the naked eye, under the microscope, but particularly with modern examination methods and equipment in order to find visible and invisible traces of one-time painting. It is incredible what Brinkmann has found on both famous and less well-known statues, reliefs and fragments.

Where beholders can, with the naked eye, only see a more or less smooth marble surface or only the odd chink or line, it suddenly

2 September 31 — Octavian is victorious over Marc Anthony and Cleopatra at the Battle of Actium
30 — Marc Anthony and Cleopatra commit suicide; Octavian enters Alexandria

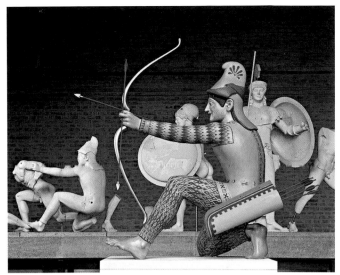

> "It may appear striking and strange to our modern taste to see marble statues that were partially painted in their complete design, as well as hearing about temples that were painted inside and out and whose ornamentations were indicated in many colours instead of being engraved."
>
> Johann Martin Wagner, 1817

becomes clear in what wealth of shapes and variety of colours the sculptures were once covered: the garments and armour of gods, heroes, and simple people were decorated with palmette and meander patters, wild animals, mythical figures and figural scenes. The works were covered in a veritable pyrotechnic display of colours such as green, blue, pink, yellow, violet, red and other hues. Evidently not a single centimetre of the marble remained untouched – it merely seems to have been understood as an excellent canvas. This presented a bitter truth for many a lover of the classic style.

Indeed even the icon of the Classical period par excellence, the Parthenon on the Acropolis in Athens, was colourful. Brinkmann was able to prove on the figures of the famous *Pan-Athenaean frieze* (ill. p. 71) for example that the painters no longer applied the colours in pure form and clearly separated individual colour fields as they did in archaic times, but that they mixed the colours and with the thus enlarged colour palette they set clear picturesque accents that made use of perspectives: folds were accentuated by darker colour tones, garments and hair could be represented iridescently – a form of painting which fits in with our understanding of art, and one we already know well from surviving Greek and Roman wall paintings.

Even if the readjustment from white to colourful is still difficult for many people, and despite many a reservation – particularly in expert circles – there is no longer any reasonable doubt that Greek artists saw their works as completed only when they were rendered colourful. This statement can be illustrated by an artist-anecdote handed down to us from Pliny the Elder. When the famous sculptor Praxiteles was asked once which of his marble sculptures he liked the most, he is said to have replied "quibus Nicias manum admovisset" (those Nicias got his hands on). The equally famous painter Nicias was thus not only appreciated for his paintings but also for his "circumlitio" – his "all-over painting" of statues.

Sure, some people may find the reconstructions as "primitive" or "kitschy", disparaging them as fit for shop-window mannequins. However, this work in progress, which tests its own procedures again and again by constantly honing its methods, is not attempting to regain the individual artistic quality of the original. The goal is to achieve the best possible approximation to the pristine appearance. Despite open questions and considerable sniping, Brinkmann and his adherents have shown the necessary courage as already demanded by the excavator Georg Treu in Olympia more than one hundred years ago: "I know that such an attempt on great and popular artworks will seem folly to some and offensive to others. However, the adventure, dangerous as it is, has to be risked at some point if our conception of ancient polychromy is not going to remain theoretical talk."

27 — Octavian receives the title "Augustus" – the revered one

Dipylon Amphora

Clay, height 1.62 m
Athens, National Archaeological Museum

The farewell to a deceased person was among the subjects of Greek art from very early on, particularly in vase painting. The scene on this large amphora from the necropolis in front of the Dipylon, the "double city gate", in Athens is among the most famous representations of the "prothesis", the mourning of the dead. Another important motif at the time was the depiction of the "ekphora", the solemn cortège of the deceased to the burial site. The positively monumental vessel, which also served as a tombstone for the dead person, is one of the most beautiful testimonies of geometric art around the middle of the 8th century BCE. Only the members of the Athenian aristocratic families with sufficient power and wealth at their disposal were able to afford such elaborate tomb decorations. We do not know the name of the painter. Hence scholars have decided on a surrogate name. In this case the unknown artist has gone down in art history as the "Dipylon master", a reference to this amphora. The black base is followed by one ornamental frieze after another right up to the rim at the neck, likewise set off in black. The sequence is broken only by the prothesis scene between the two handles and the animal friezes with foraging deer and wild animals in their lair. Alongside dots, rhombuses, or lancet-shaped leaves it is particularly the wealth of variations on what is probably the most famous ornament of Greek art – the meander – that is the most surprising: the body, shoulders and neck of the amphora are all covered by castellated, stepped, double and triple meanders, filled in with delicate diagonal lines, in meticulous execution. The ornaments are hardly to be understood as abstract patterns. Rather, they represent tendrils and other plants; together with the animals they constitute a shorthand for life in general – for flora and fauna. In the centre of the picture the dead person is lying on a bed of rest, a "kline". Above him one can recognize the shroud decorated in a chequerboard pattern that actually covers the body. Mourning women are sitting and kneeling in front of the death-bed while men are standing to the left and right, recognizable on the left for example by the girded swords, and likewise depicted with the familiar mourning gesture, i.e. with raised hands pulling at their hair. Women and men seem at first to be depicted in the same way: head and feet seen from the side, the triangular body by contrast from the front; knees, waist, and neck are emphasized as important joints in the human body. It was the body that was the focal point of the artistic interest of the time, not garments and other pieces of clothing that beholders must of course imagine for themselves. In the 8th century BCE this body was understood less as a unit than as an organism composed of important individual parts. Accurate matches of this image of the human being of the Geometric era are described in Homer's epics. There, heroes have broad shoulders and strong thighs, they are fleet of foot and supple in the knees. Some verses of the Odyssey serve as an example of how important these bodily strengths were in the minds of the people. The hero Odysseus, dressed up as an inconspicuous beggar, challenges the suitors to a competition in his house and for this purpose ties his garment around his waist, (Odyssey 18, 67–71) "thus baring his stalwart thighs, his broad chest and shoulders, and his mighty arms; but Minerva came up to him and made his limbs even stronger still. The suitors were beyond measure astonished …" (translation by Samuel Butler). This is absolutely the description of a human body as shown on the Dipylon amphora.

Funeral carriage in solemn cortège, detail from a krater from the Dipylon Cemetery

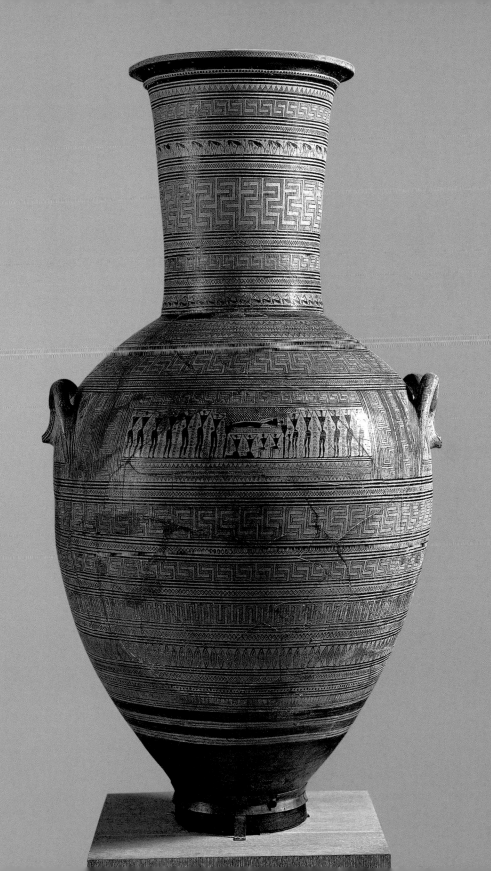

Tripod cauldron

Part of a cast tripod leg, bronze, length 46,5 cm
Olympia, Museum

The career of the artefact category "tripod cauldron" lasted several centuries, from around the 9th century BCE right into the Roman period. During that time the tripod cauldron underwent a transformation from the purely utilitarian object that stood on its own feet above the fire and could be carried away from the hearth with a pole stuck through the two round handles, to a sumptuously decorated gift not only for gods but also for victors in athletic and musical competitions. During this process the format increased from a size suitable for everyday use to metal structures a good three metres high. The part shown here of a cast-bronze tripod leg with illustrations comes from one of the typical examples whose fragments were found in large numbers during the excavations in Olympia. It still belongs in the 8th century BCE, that is to say into the Geometric era, as is easily recognizable by the two figures depicted in the upper part of the picture. While the feet of the so-called "ridge-leg" tripods are normally decorated with vertical, step-like ridges layered out from the middle axis, which, by the way not coincidentally, recall the flutes of Doric columns and their load-bearing functions, the tectonic purpose of this ornament is lost here, because the ridges are interrupted by the image fields and now merge as rectangle patterns. In the upper image field, two opponents are arguing and are getting ready to throw a punch with clenched fists. Both are wearing a helmet, as can be seen by the stylized helmet plumes, and both are reaching for a tripod with their other hand, or rather they are both tugging at it. The knees of the two adversaries are in this case not bent to the same extent, so that a staged, indeed a particularly dramatic, element is included here, despite the mirror-image composition. It used to be thought that this image depicted on the Delphic tripod was the mythological argument between the divine heroes Heracles and Apollo. The current interpretation leans more to a purely athletic competition. The reach for the tripod should be understood as the goal of the competition, not as a tugging at the victory trophy.

Such a tripod cauldron had considerable material value. It could also be presented to an esteemed guest as a valuable farewell gift. Thus it says in the "Iliad" (23, 700ff.) that during the funeral games in honour of Patroclus the audience and the participants valued such a tripod as equivalent to twelve oxen. The image field below the two rivals depicts two lions standing on their hind legs, their jaws wide open, and their front paws set against each other. Between them can be seen petals open like chalices − they are meant to serve as the shorthand for the motif of the "tree of life" taken over from the orient. The symbolism of later heraldic lions that stands out to the eyes of the modern viewer is unmistakable. The close proximity of the two lions does not however indicate a static composition, but rather a realistic fight between the two animals. Thus it stands to reason that one should connect the two fight scenes, true to the familiar image of the hero who fights like a lion. Exactly this image is also prevalent in the "Iliad" (7, 256), which was written down during those decades. Thus for example the duel between Ajax and Hector, where the two fighters attacked each other like two lions. The picture motifs on this tripod leg are to be "read" thus: the two warriors are battling with lions' strength and with great anger for the trophy that is waiting for the victor − i.e. just such a tripod cauldron.

"For the Danaans, Peleus' son then set out / a display of prizes for the third contest, / the hard-fought wrestling match. The winning prize / was a huge tripod to place above a fire, whose value among themselves Achaeans set / at twelve oxen. Into the middle of the crowd / he then bought out the loser's prize, a woman / skilled in every kind of work, worth four oxen."

Homer, The Iliad 23, 700−705

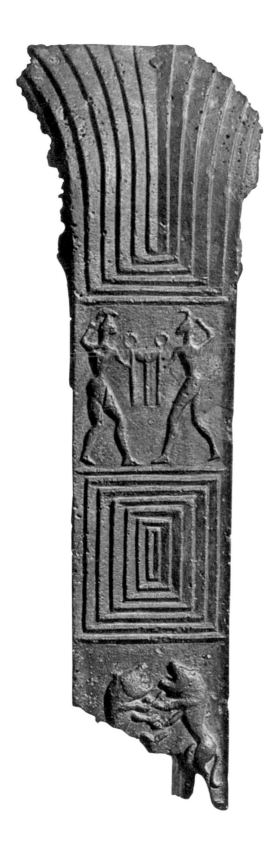

Lion God of Delphi

Ivory, height 22.5cm
Delphi, Archaeological Museum

It took some time after the collapse of the Mycenaean civilization for society to re-group in the Greek homeland and to culturally re-appear on the stage of world history. with a few exceptions, there are hardly any noteworthy material legacies dating from this period. These Greek Dark Ages lasted from around 1050 to 800 BCE. However, the situation quickly changed with the rise of Greek cities in the western and eastern Mediterranean, as well as on the shores of the Black Sea. The people began forging stronger and tighter bonds with their neighbours. Trade with the civilizations of the Near East and with Egypt flourished. However, forays, raids, and wars, as well as gifts, brought new goods into their old home. Thus the Greeks became acquainted with other customs and practices and experienced wealth, pomp, and luxury as they had never seen it before. Elaborately decorated gold jewellery, valuable ivory carvings, and richly embroidered cloth all found their way into the houses of Greek aristocratic families. They of course clamoured for more. The local traders and artists must certainly have responded quickly to this new market. They analysed their customers' taste and went on to create numerous works that did not deny their Oriental models, but did emphasize their own opinion of the mythical creatures and gods, or they used ornaments and animal depictions in different contexts. Literary reflexes of such artworks and weapons are also handed down to us in the early Greek epic. There they are often referred to as heirlooms or mentioned in the inventory of the royal treasury. Even Achilles' shield or Athene's helmet in the "Iliad" recall Oriental, Egyptian, and Cypriot influences.

It was also in this fertile area of conflict between East and West that this little ivory statuette was created. It was discovered together with other damaged votive treasures made of gold, silver, bronze, and ivory in the Temple of Apollo in Delphi in 1939. The figure of the spear-holder with a big cat by his side — it is not clear whether it is a lion or a panther — is standing on a leaf-covered capital whose plate is decorated with a carefully worked meander pattern. The face is framed by a beard and the eyes were set in a different material. The cloak is opened beneath and thus provides a view of a strong leg. The statuette was designed to be viewed from the front. The back is noticeably flatter. Originally it would have been part of a piece of furniture or another object. This is suggested by the peg on the underside and another in the back. The figurine was therefore part of a decorative context. The motif is certainly based on Oriental models. It has however been modified slightly. Thus one is familiar with lions that try their strength against gods and heroes with splayed paws. The lion's proximity to the spear-holder on the other hand is not familiar. It seems to serve the latter as a support and thus gives the scene an almost heraldic effect. The spear also acts less as a defensive weapon than as a sceptre. It remains uncertain whether the presumably Greek artist wanted to depict a deity or a mythical figure. He did however use eastern influences and created something personal — a further step towards the development of an individual style.

> "The Greeks who have a different opinion of this origin [of the arts] claim that the first statues (according to Diodorus) were invented by the Ethiopians, then taken over by the Egyptians, from whom the Greeks took them over, since even in Homer's time sculpture and painting were evidently perfect, as that godlike poet attests to in his descriptions of Achilles' shield, which with all artistry he describes to us as more sculpturally formed and painted than described with words."
>
> Vasari, Preface to the Lives, 1568

тhe κore of Αuxerre

Limestone, height 65 cm, with base 75 cm
Paris, Musée du Louvre

According to the mythological tradition Daedalus was an inventor, a master builder, a craftsman, and an artist. After killing his nephew he was banished from his home town of Athens. He found asylum with King Minos on the island of Crete. There he built a prison – the Labyrinth – for the bull-headed monster, the Minotaur. Daedalus, who was already mentioned in Homer's "Iliad" (18, 590 – 592) was considered the founding father of all visual arts. It was said he made his statues come alive through open eyes and seemingly movable limbs. Thus it is understandable that scholars labelled the style of the earliest large stone sculptures, whose composition left the Egyptian and oriental models behind, "Daedalian". Important witnesses of this new start in the 7th century BCE are known. They were created on Crete, where Daedalus had found a new home. The form principles of the Daedalian style are particularly visible in small artefacts. A certain simplification and systematization in the structure of the figures is characteristic. This structure is especially noticeable in the consistent frontalization and integration into an orthogonal axis system. The face is of triangular shape and is framed by a hairstyle combed down across the forehead. Only later do the facial shapes become rounder and take on a more three-dimensional quality.

This development is also displayed by the less-than-life-sized statuette from Auxerre. It documents the Daedalian style particularly clearly. At the same time it is one of the earliest known "korai" in Greek art. The effigy of the young woman with her feet close together is mounted on a base. Thus she is not striding, like the "kouroi", the archaic effigies of men. This symbol of athletic and bellicose proficiency was of course not permitted for representations of women. The left arm is close to the body and the right hand is pressed flat on the chest. The triangular face with the big, almond-shaped eyes is framed by an extremely voluminous head of curls falling over the chest and back. Above the forehead the hair is twisted into little corkscrew curls. The mouth already displays the famous smile of the archaic representations of human beings, such as we know from "korai" and "kouroi".

Ancient observers must have understood this smile in the same way as we do, as it was typical of Aphrodite, the goddess of love. In addition it was also a symbol of vitality and sensibility – since a dead human being is no longer able to smile. The "Lady of Auxerre" is clad in a long gown. Her shoulders and arms are covered by a short mantle, which is usually called an epiblema. Below the bow-shaped hem of the gown one can only see the tips of her toes. A broad belt girds the narrow waist. Several rectangular areas structure the skirt vertically below the belt. At the lower end of the pattern can be seen a row of parallel carvings that can only be the creases of a thin undergarment. The square and rectangular areas represent woven patterns that were originally – like the entire figure – painted. This emphasized the preciousness of her gown as well as making a visual distinction between her over and undergarments possible. The part of the gown above the belt was decorated with a scale pattern. The careful reproduction of the finger and toenails documents the effort with which this unknown Cretan artist created this little masterpiece of early Greek stone sculpture.

> "Great Daedalus of Athens was the man / Тhat made the draught, and form'd the wondrous plan; / where rooms within themselves encircled lye, / with various windings, to deceive the eye."
>
> Ovid, Metamorphoses 8, 158ff.

griffin Head

Bronze, height 28 cm
Olympia, Museum

Those who felt indebted to a god or a goddess – be it through a vow, a victory, or re-gained health – usually paid off this debt by dedicating a gift to the deity in his or her temple. The value of this offering naturally depended on the wealth of the individual. Whereas a simple peasant was only able to afford a small clay statuette – perhaps depicting an ox or a sheep – a powerful person from the political elite of his home town or an entire "polis" had quite different possibilities. These were of course exploited, because one considered oneself in competition with other aristocrats or polities when it came to the display of pomp and gifts to the gods. Everyone wanted to be better, to outdo the other. In this way it was particularly the large trans-regional temples of Greece, such as those in Delphi or Olympia that filled up quite quickly with numerous votive gifts over the course of the centuries. Pausanias (c. 115 – 180 CE), the most famous travel guide of Antiquity, came across a forest of statues during his visit to Olympia. Archaeologists have been able to prove that the responsible priesthood there had had older votive gifts cleared away and buried centuries before because of a lack of space.

Amongst the older votive gifts dug from the Olympian soil was the head of a griffin shown here, a replica made soon after a famous archaic bronze work which is justifiably considered amongst the most significant sculptural creations of the 7th century BCE. The artist who realized this "griffin of all griffins" in cast bronze around

Singer with lyre, 8th century BCE

640/30 BCE captured the metal in a grandiose form full of inner tension and rhythm (The replica shown here includes also a long, elegant neck). At one time the head, along with other griffin heads, adorned a so-called griffin cauldron as decoration. This type of votive gift started appearing alongside tripod cauldrons in Olympia and other temples from the second half of the 8th century BCE. In contrast to the tripods, the early griffin cauldrons, which came from the Orient, did not have legs, but sat on a usually richly decorated stand, from which they could be removed. Various decorative elements – known as "protomai" – could be attached to the cauldron shoulder: bull and lion heads for example, but also hybrid beings and fabulous beasts. It was not long before the Greeks started their own production of such cauldrons. They tamed the oriental mass of decorations and canonized this cauldron shape by limiting themselves to griffin "protomai". These however were raised to the highest perfection with their artistic finesse, as is demonstrated by this example. And as was the case with the tripods they created these griffin cauldrons in monumental dimensions. By safeguarding the statics with a sophisticated repoussé technique, the "toreutes" or artists in metal managed to create specimens of three and a half metres in height and more. The pervasion of the Greek world of forms and conceptions of art with those from the Orient can be seen in this genre in a unique way. Oriental ideas quickly reached the Greek world in the newly founded colonies and also in the homeland. It was these models and impressions that the Greeks finally transformed into new forms with their own ideas.

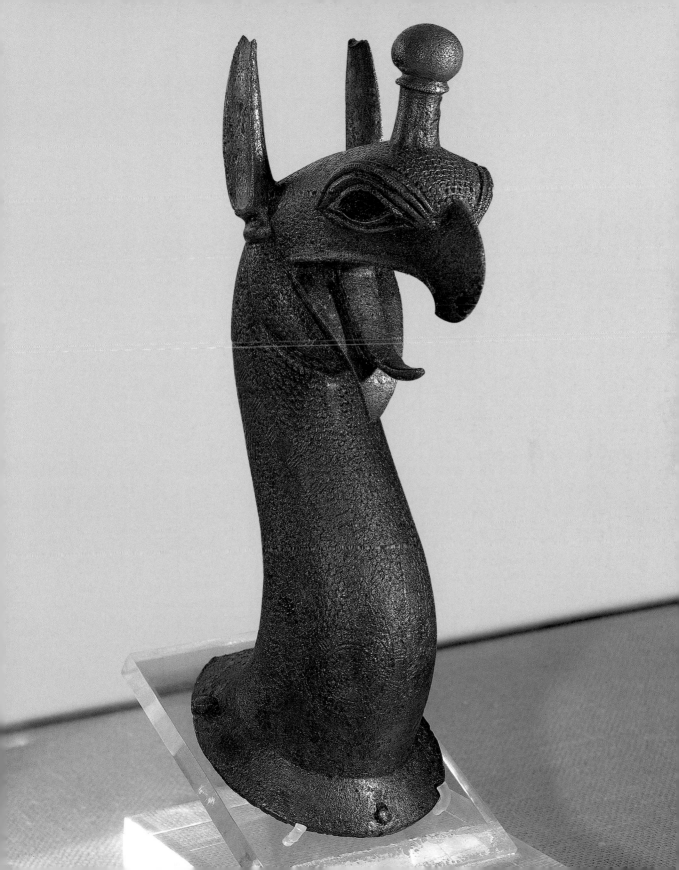

statuette of a Dancing youth

Ivory, height 14.5 cm
Samos, Vathy Museum

Amongst the rare discoveries of significant artworks dating from Greek antiquity – and particularly from the earlier centuries – are those pieces that are not made of stone (mostly marble) or metal (mostly bronze). However, that does not mean there were no or few works made of wood, precious metals, or ivory. Such valuables were part of the household effects of the rich and powerful. They were also among the gifts or votive offerings in the inventories of famous temples. In addition the carving of wood or ivory was still practised in later centuries. We need think only of the over-life-sized gold and ivory statues of the goddess Athene built on a wooden frame in the Parthenon on the Acropolis of Athens, or of Zeus in his temple in Olympia – both works of the sculptor Phidias (active c. 460 – 430 BCE). Some valuable pieces made of these materials were also mentioned or described in the surviving written sources. However, gold and silver were too precious to be buried in the ground except in an emergency

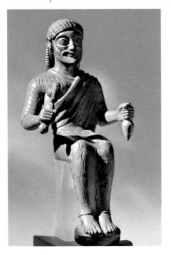

Enthroned Zeus, c. 590 BCE

and perishable materials such as wood or ivory mostly decomposed. Numerous valuable pieces come from the Temple of Hera on the island of Samos. Here the marshy area allowed their conservation by excluding the air. One of the rarities found there was the ivory statuette of a youth with a nearly undamaged surface. Despite its small format the artist was able to give the masterpiece a monumental effect through his careful carving and attention to detail. It is no doubt a highlight of early archaic carving. The youth's only item of clothing is a broad, richly decorated belt – an indicative symbol of elegant clothing – as well as finely laced half-boots of soft leather. The eye of the beholder is automatically steered towards the head sitting on a strong torso with clear accentuation of the collar-bones, muscular chest, and costal arch. The long, narrow face is dominated by the large eye sockets that originally contained eyes of another material. The eyebrows, ear jewellery, and pubic hair were also made of another material. In addition, filigree carving and inlay work can be seen on the youth's coiffure. The hair, formed in a fine fishbone pattern, is tied into four plaits of which two fall over the shoulders to the front and the two others over his back. A double ribbon knotted at the back of his head provides both support and decoration. The hair of his forehead is twisted into four corkscrew curls whose centres are each decorated by a tiny flower made of amber. The youth is not depicted kneeling down, rather he is jumping. His half-boots seem to mark his action: he is performing a "leaping dance". Male participants had to perform the highest leaps possible to the sound of a flute. There were evidently even competitions in this discipline, also known from vase paintings. The statue's technical execution – a borehole goes through his head and chin – show that this youth must once have been part of a piece of precious apparatus. It used to be thought that it was used for a lyre, these days however scholarship favours its use as a container carrier. Whatever his context, the youth from Samos documents the high skill of the archaic ivory carvers and he gives us a glimpse into the world of the aristocracy who were able to afford such treasures and who also sought competition in dancing.

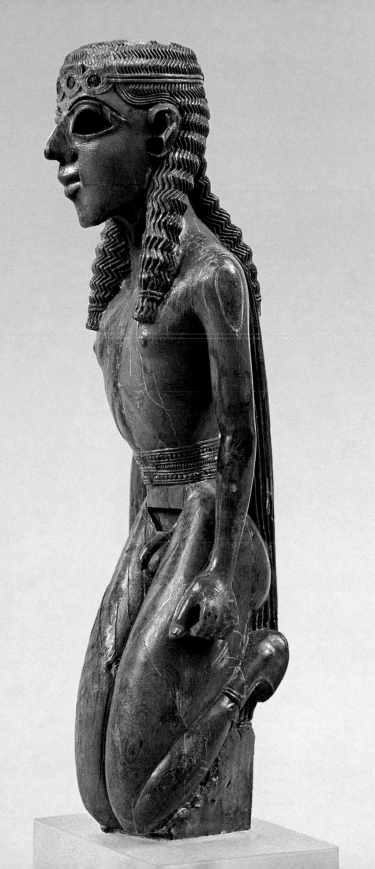

Funerary statue of a youth from Attica

Marble, height 1.85 m
New York, The Metropolitan Museum of Art

The sight of an archaic statue of a youth, a "kouros", automatically reminds viewers of similar statues from pharaonic Egypt which also depict a man standing with his left foot forward. And it really was Egyptian models that inspired Greek sculptors to take the depictions of the naked man in art and make them in life-sized and monumental formats. From the 7th century BCE on, Greek art had developed such independence that it did not only take in influences from the Orient and copy them in individual motifs onto vases and other works. Rather, artists took in these numerous inspirations and created their own, new artworks. They did not deny their oriental models, but these did bear a Greek signature – one should remember the *Griffin Head* from Olympia (ill. p. 35). This is also true of the "kouros" presented here. The connections between Greece and Egypt in the 7th and 6th centuries BCE via colonization and trade were close. Ancient written sources tell us that Greek artists learned Egyptian sculpting techniques and stoneworking. Nevertheless the appearance of monumental sculpture in Greece occurred almost suddenly, and, in this form, unpredictably. Alongside characteristic features which they had in common, a comparison between Greek "kouroi" and Egyptian statues immediately shows their differences. Their common features are the upright posture with the left foot forward, a broad chest, arms hanging down at the side of the body at a slight angle, hands made into fists, as well as the raised head looking straight ahead. However, this Greek youth is standing unsupported without the obligatory Egyptian back pillar. In addition he is naked and insofar hardly comparable to the Egyptian representations of men, who are clad in loin cloths.

The slightly over-life-sized "kouros" in New York is the earliest almost undamaged example of its kind known to us. It was found along the road connecting Athens and Cape Sounion close to the village of Anavyssos. The statue was not a votive gift in a temple but the tombstone of a youth who either died young or fell in battle. One's eye is drawn to the evenly elongated facial oval with the high forehead. The thick, shoulder-long hair is falling onto the nape of the neck. The carefully worked locks are held at the back of the head by an artfully tied ribbon. Around his neck the deceased is wearing a circlet. On a closer look one can already see the body's tectonic design assembled with load-bearing and loading parts – at around 600 BCE an early prelude to the Greek image of the human being that was to receive its classically valid form a century and a half later. The sculptor successfully managed to vividly represent the functional connections of the human body.

The not very naturalistic forms of the muscles and bones recall artworks of the 20th century in their abstraction – a language of forms we are familiar with. Thus the shin of the "kouros" is overlaid by the kneecap like a capital, over which the tensed thigh muscles are lying. The statue's plasticity was originally enhanced by the obligatory painting, of which a few remains have survived. Thus for example there are traces of red paint on the hair band. Particularly the eyes, hair, mouth, and nipples were coloured and gave the statue with its brownish-tinted surface a more animated appearance despite its abstract form.

"It sufficed for an effigy to be faithful to the truth, to be the most beautiful of all, and to pass on that immortal serenity, which elevates the God above us."

Hippolyte Taine, The Philosophy of Art, 1882

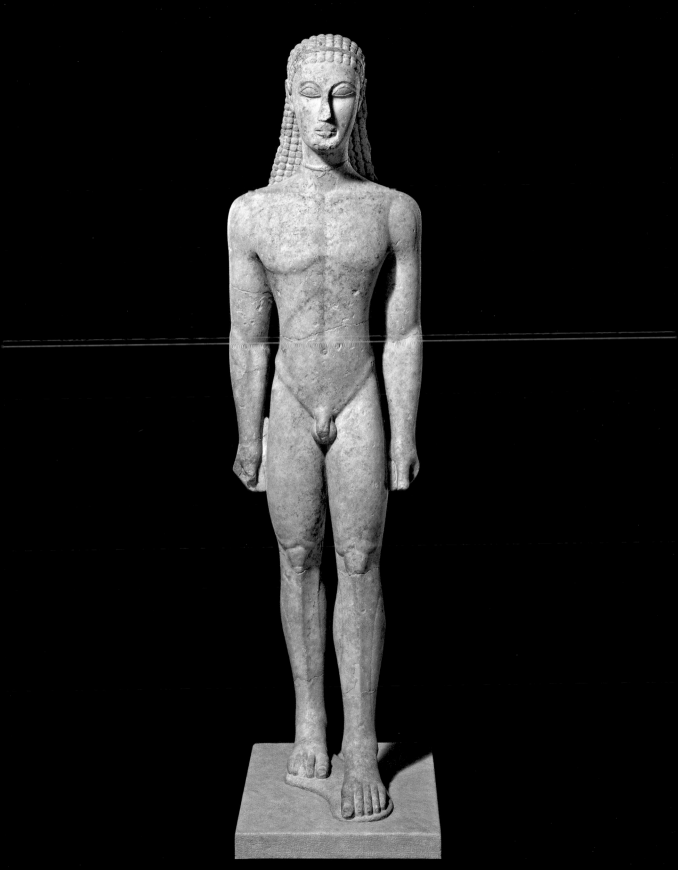

Achilles and Ajax playing a Board Game

Amphora, clay, height 61 cm
Rome, Vatican Museums

Neither the vessel's form nor the subject of the depiction are unusual. The shape of this amphora, of this classical storage vessel for wine, olive oil, or also for solid food, is the same as that of many other amphorae. Incidentally we know the two boardgame-playing heroes from around 70 other representations. What distinguishes the black-figure vase shown here is its masterful quality. This is no wonder, since it was made and painted by a master of the craft: Exekias. It was once said of him that he took the step from craft to art. However, in actual fact he did not introduce any new elements to vase painting. Thus this assessment simply substantiates once more the fact that Greek vase painting is an art – and a very significant one at that – even if ancient sources did not recount much about it, in contrast to sculpture or panel painting. The painted vases were not only esteemed by the Greeks in the mother country, they were indeed exported particularly by Corinth and later also by Athens, which dominated the market, to the colonies of the eastern and western Mediterranean. The Etruscans in Italy were also enthused by the clay artworks and took thousands of them with them into their preciously appointed grave complexes. Since the first painted vases were not discovered in Greece itself but in Italy, particularly in Etruscan cemeteries, it was originally thought the Etruscans were the creators of these artworks. Exekias' amphora is also from Vulci in Etruria.

The image composition is calmly harmonious; the drawings are of outstanding skill. Exekias recorded his authorship as potter and painter in calligraphic inscriptions and also removed any uncertainty for the understanding of the representation. Achilles and Ajax are sitting across from each other on low stools. Between them is a further stool on which the board game is lying. Bent forwards and completely absorbed by the play of the dice, Achilles is saying "four" and Ajax "three", as can be read on the inscriptions close to their mouths. Thus Achilles with the splendid helmet on his head wins the game, Ajax, who seems to have slipped forward in excitement, has lost. The image's composition follows symmetrical principles, but the smallest differences, such as only Achilles wearing a helmet or the moving forward of one of the players loosens it up. The same can be seen with the lances that, while crossing at the centre of the picture, do so in different planes. The two shields leaning on the wall have the same shape, but they display different motifs: on the left an "ipotane" head above a panther, on the right a "gorgoneion" above a snake. Over their armour the two heroes are wearing grandly decorated garments, whose ornaments have been rendered in admirable fineness. Exekias carefully carved meanders, plaited bands, spirals, stars, and more. It is surely no coincidence that the hair band and the curls above Ajax's forehead recall the archaic "kouroi", the marble youth statues. Their carefully finished hairstyles tell the observer that those depicted had the time to take care of their aristocratic appearance in order thereby to bring across the ideal of external beauty and internal values. The heroes Achilles and Ajax also embodied this Greek ideal, of course.

"Those who do not value painting scorn the truth and do wrong by the understanding of art as concerns poets; because both arts concern themselves with the deeds and characters of heroes; they also enjoy the harmony through which art also participates in the logos."

Philostratus, Eikones, preamble [Pr. 1]

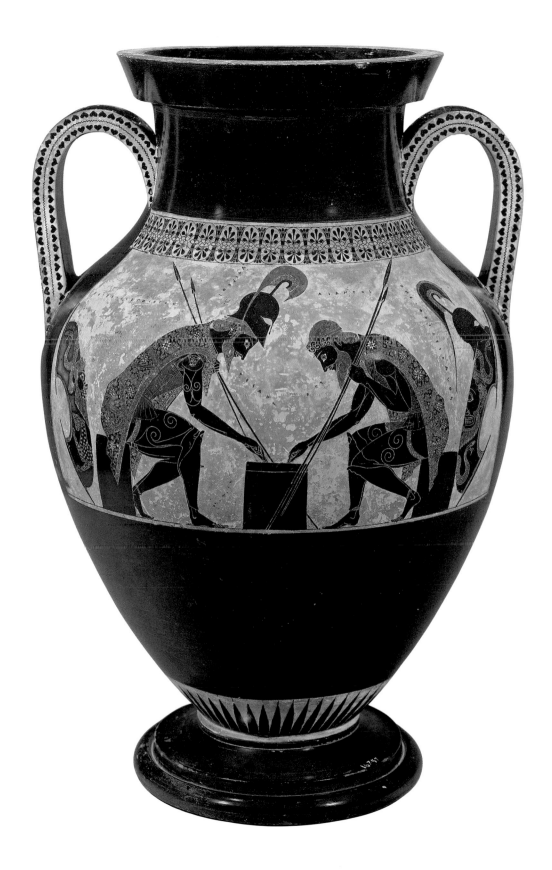

Funerary statue of a youth from Anavyssos, so-called Kroisos

Marble, height 1.94 m
Athens, National Archaeological Museum
==

Just like its counterpart in New York (ill. p. 39), this "kouros" also crowned a grave mound and was found in Anavyssos. A three-step base also found there seemingly served as a platform, whose epigram provides the name of the deceased who died in battle: Kroisos. The type is the same, but what a difference compared with the older statue: a completely different impression of the body is manifested here. Instead of subtle-reserved shapes, Kroisos' body is marked by a strong plasticity that does not however cover the skeleton below it. The warm brown tone of the surface, which seems almost alive, is probably the result of the sculpture's long sojourn in iron-rich soil, but this statue also has traces of erstwhile painting. On the powerful body sits the rounder head whose long, heavy falling hair-curls frame the strong neck. The eyeballs are slightly curved and together with the carved pupils and the traces of colour they create a lively facial expression. On his head Kroisos is wearing a thin cap made of leather, under which his hair emerges in waves – proof of the sculptor's skill. Above the forehead the hair is dressed into rows each of five inward-turning snail-like curls that become larger and fuller towards the ears. The torso, the arms which do not touch it, and the legs are still bound to a more schematic composition, but the swelling forms make for an alive expression. The arms are meaty, the legs are powerfully built, and the upright and stretched upper body is muscularly formed.

There is no doubt: the statue of Kroisos is a splendid symbol of the norms of the rich and powerful and their attitude towards life. It once again visualizes the ideals of the Greek aristocracy. The naked, well-formed, physically fit body documents the physical capacity of the one portrayed, irrespective of whether he possessed this in real life or not – the point was the representation of an abstract ideal.

Nudity distinguished the Greeks from (dressed) barbarians in art, particularly from the Persians who were considered effete and against whom the physically strong Greeks had been victorious. The positively artificial design of the long hair styles, carefully tamed with a hair band or a cap showed the depicted person as a member of the social upper class. The lifestyle of this upper class included elaborate care of body and hair. This way of life where an individual, free from all physical work, could compete in athletic and mental competition with his peers was something only the aristocracy could indulge in. It was also the aristocratic families that possessed the financial means for the erection of such "kouroi". Ability to move was thus the key concept in the representation of the naked male – regardless of whether in the real or in the abstract sense. However, the archaic sculptors by no means attempted to illustrate this ability to move by depicting a body "moving naturalistically". It did not take long for the strict arrangement of the archaic representation of the body to loosen up. The knees were no longer rigidly stretched, but appeared to be giving way slightly. The head was tilted slightly facing the observer. These were seeming trifles, but in their effect on the human image in Greek art they should hardly be underestimated.

"The people of those times watched the body naked and in motion in the baths, on the sporting fields, in the sacred dances, and in the people's games. They nurtured and loved those parts of its shape and posture that expressed masculinity, health, and youthful vivacity. They used all their efforts to shape it into these forms and to teach it these postures. Over three or four hundred years, that is how they improved, refined, and developed their idea of bodily beauty. So it is no surprise that they finally managed to discover the ideal model of the human body."

Hippolyte Taine, Philosophy of Art, 1882

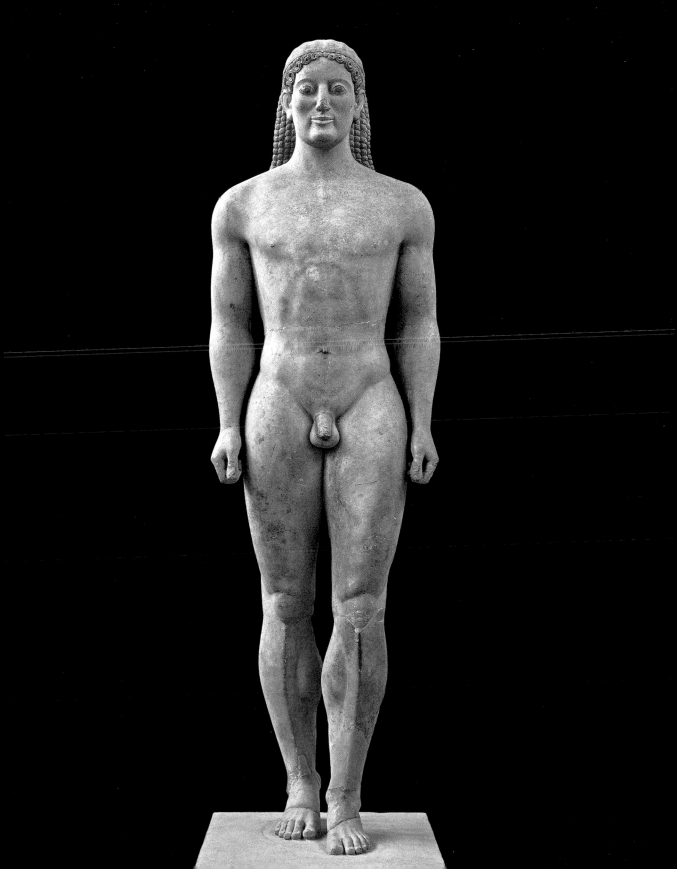

statue of a Girl, so-called Peploskore

Marble, height 1.20 m
Athens, Acropolis Museum

Amongst the numerous depictions of girls or young women – "korai" – that had been dedicated to the patron goddess by influential Athenian families in the 6th century BCE was this expressive and pillar-like marble statue that enjoyed special interest right from its discovery in 1886.

While the "korai" on the Acropolis and in other places too wore the finely woven pleated chiton artistically draped around their body, and lifted the long gown somewhat with their left hand in a graceful gesture as if they thereby wanted to make it easier for themselves to walk, the "kore" with the inventory number 679 showed quite a different appearance. The right arm is lying at the side of her body, while the left arm is outstretched. This excludes the statue from the iconographical framework of this group of girl statues. She is neither to be broached as a "kore", nor is she wearing the customary diaphanous Chiton. In the tight, unpleated gown, archaeologists thought to recognize the sleeveless, woollen "peplos" and labelled the figure *Peploskore* from then on. However, the dress does not have much to do with a classical "peplos". It was only the current investigations on the original, which did not have to limit themselves to the still-present colour traces but also made traces no longer visible to the naked eye visible once more, that made possible a reconstruction of the original colour, the ornaments, and the figural embellishments. These results in turn allowed a correct identification of the gown and thus the correct naming of the *Peploskore.* The coloured and supplemented reconstruction shows that over a finely pleated chiton, the statue is wearing a tight-fitting, smooth gown and an ankle-long waistcoat-like garment with a short shawl, whose hem is decorated with a frieze of lotus flowers and palm leaves. The front of the gown visible under the slightly opened "waistcoat" shows a vertical stripe on which several animals and fabulous creatures are arranged one above the other. Thus one can recognize a sphinx, boar, ibex, and a lion, but also a horseman. This unusual and splendid animal-frieze gown is evidently an "ependytes", a gown originating from the Orient and there reserved for the ruler. In the Greek cultural area on the other hand it was reserved for some leading female deities, for example for Artemis in Ephesus or for Hera on Samos, but also for Athene.

The statue's gown and posture thus make it impossible to interpret her as a normal girl. The representation of a goddess is much more likely. Doubtless it is not for nothing that the colouration – white to orange-pink skin, gold-ochre coloured gown – recall the tradition-rich images of gods in gold and ivory technique, such as the *Athene Parthenos* or the *Zeus of Olympia.* If archaeologists initially thought that in the *Peploskore* they could be looking at a cult image of Athene, mistress of the Acropolis, complemented with a lance and shield or a helmet, these days they lean towards another interpretation. Drilling of the marble statue suggests that it once had a crown of rays, as reserved for Artemis, goddess of the hunt – and Artemis was also worshipped on the Acropolis. She would then have been holding arrows in her right hand and a bow in her outstretched left hand.

However, despite the small lingering uncertainty in labelling her: the *Peploskore* is amongst those artworks that can only be correctly interpreted through the re-discovered knowledge of former colouration and which thus enrich our knowledge with important insights into the art and life of ancient Greece.

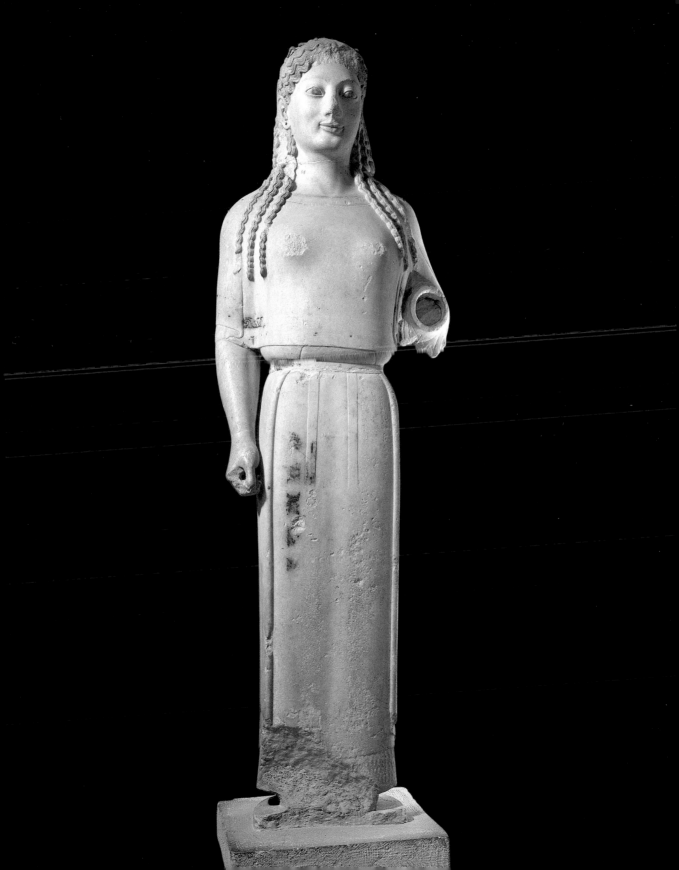

Heracles at a carousal

Amphora, clay, height 53.5 cm
Munich, Staatliche Antikensammlungen und Glyptothek

Around the year 530 BCE a new technique for the decoration of clay vessels was invented in the workshops of Athenian potters, whose triumphal procession became unstoppable with the beginning of the new century: the red-figure painting method. It was basically the reversal of the thus far customary black-figure painting technique, because thereafter figures and ornaments were left out when the rest of the vessel's body was painted black. Possibilities of differentiation that had not hitherto existed now became available to the painters – but the new techniques also required more care and skill. The change naturally did not take place from one day to the next. There was, rather, a transitional phase during which both techniques were practised side by side. On some vases painters demonstrated their ability in a special way by creating so-called bilingual vessels displaying both red-figure and black-figure images. The amphora depicting the drinking Heracles, signed by the potter Andokides, is also amongst this group. The Andokides painter. named after the workshop owner, is even considered the inventor of this innovative technique.

Already on the Munich amphora the superiority of the red-figure painting becomes clear, as does the way the different dramatic possibilities of the imagery are tested. The subject is the same on both sides: Heracles, the Greek hero par excellence, has settled down on a "kline", a resting couch, for a drinking session. On the black-figure side he is lying flat, holding the large drinking cup, the "kantharos" in his right hand and looking at the goddess Athene standing before him. Behind her one can make out Hermes with his winged boots and his travelling hat. On the other side a naked servant is seeing to a big wine-mixing vessel. In front of the "kline" one can recognize small pieces of meat, cake, and a drinking bowl on a small table. The tendrils of a vine hung with grapes frames the meeting between the hero and the gods. Even though the composition of the red-figure picture only leaves out a few elements – the messenger of the gods behind Athene, the drinking cup, and the weapons hanging above Heracles – the scene still has a calmer effect. One almost wants to say: more appropriate to a meeting between a demigod and a goddess. Each is more isolated and both unfold their own importance, growing in their own space. Heracles is now not just simply lying flat. He is holding his knee with his hand and is thus propping himself up. His head extends into the uppermost ornamental strip. The large, black "kantharos" suddenly becomes an important element in the picture story. The hero stretches towards the goddess, who is handing him a half-open flower with an artificial gesture. The grapevine does not simply grow out of the ground, but winds itself full of tension from the middle, and swings with its branches and shoots far into the picture. The carefully crafted meander patterns on the "kline" mattress, on the cushion, and on the border of Heracles' gown impressively show what refinements in detail the red-figure technique afforded the painter. There is no doubt that the internal painting of these textiles makes them appear more precious than their black-figure counterparts. Here Heracles appears as a mature, stately man who is only definitely identifiable through his patron goddess Athene.

Andokides amphora, red-figured

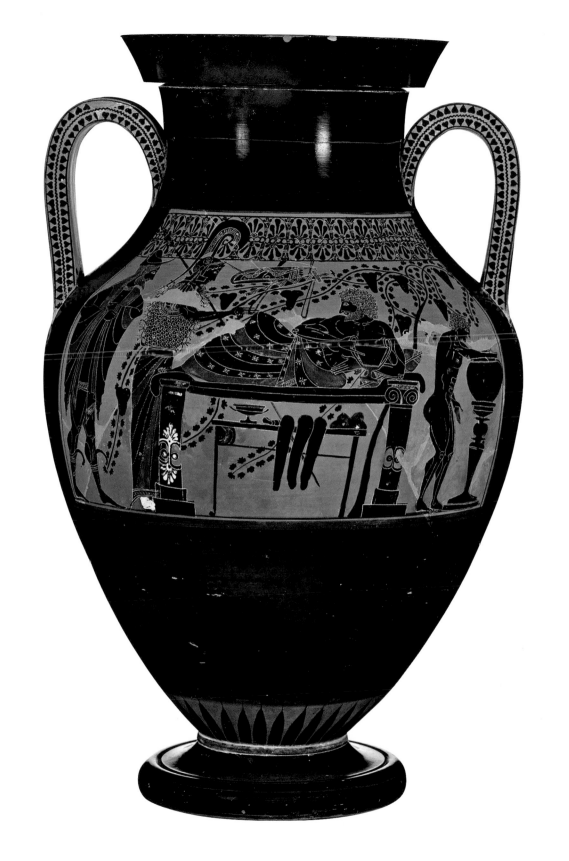

Heracles kills Pharaoh Busiris

Hydria, clay, height 45.5 cm
Vienna, Kunsthistorisches Museum

Amongst the myths about the Greek national hero Heracles is a little-known episode set in Egypt. According to the legend the Greek hero was captured during a journey through Egypt and – like other strangers before him – was destined to be sacrificed at the behest of Pharaoh Busiris. The ruler hoped with this gruesome human sacrifice to end a period of drought lasting for several years. At the altar however, Heracles tore apart his shackles and killed Busiris as well as the latter's son Amphidamas and his entire retinue. The incident has been handed down to us on various vases. The most drastic and most exuberant representation is on a Caere hydria, a three-handled vessel meant for fetching water. The labelling of this type of vase goes back to the place of discovery, Caere, in ancient Etruria – modern day Cerveteri, where most of the vessels came to light. The owners of the workshop, which produced nothing but hydrias for a generation, must have been eastern Greeks who had come from Ionia to Italy in order to produce directly for the home market. Even in Antiquity many a businessman used the opportunity to be more successful economically by opening up a manufacture on location so that he was able to react faster to the changing taste of his potential customers.

The raging of Heracles amongst the Egyptians is depicted on the body on the front of the hydria, while the picture strip below it shows a wild boar hunt. The shoulder has a myrtle wreath spreading out over it; feet, handle zone, neck, and mouth are decorated with meanders, palmette leaves and other floral motifs. The naked hero is holding two Egyptians with his hands, while he is strangling two

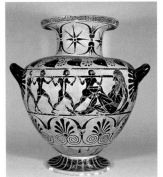

Caere Hydria with the blinding of Polyphemus, c. 520 BCE

more in the crook of his arm. He is trampling down on two further opponents with his feet. The Egyptians are marked out by their black and yellow skin, a typical "un-classical" profile, and their linen gowns or "kalasiris". Busiris – recognizable by the royal crown with the uraeus (snake) and by his beard – is already lying shackled and defeated at the foot of the altar, while others from the Pharaoh's retinue are looking for shelter there. The sheer size of Heracles, as well as the faces contorted with fear and the helpless gestures of the Egyptians, leave the observer with no doubt as to who the victor of this fight will be. Egypt was not an unknown land to the Greeks, at least by the 7th century BCE, when Greek mercenaries moved there and founded the trading settlement Naucratis in the Nile delta. The experiences with an altogether unknown culture did not lack fascination, but also aroused prejudices amongst those who felt their own identity to be threatened. Against this background the Busiris myth gains another meaning, as it serves, properly looked at, an age-old prejudice: xenophobia. The painter used the vocabulary of Pharaonic victory propaganda for his depiction, thereby beating the Egyptians with their own weapons, so to speak. Just as Heracles is trampling on the Egyptians in a sidestep, other representations show the Pharaoh at the destruction of the enemies, where he also grabs enemies by their heads or limbs, and runs over grotesquely dislocated bodies on the ground with his chariot. All these fight scenes on official monuments show one thing: this way the scene is not merely a story with drastic traits, but also a subliminal defamation of the Egyptians. In general, however, it should be said that the Greeks' admiration for Egyptian culture predominated.

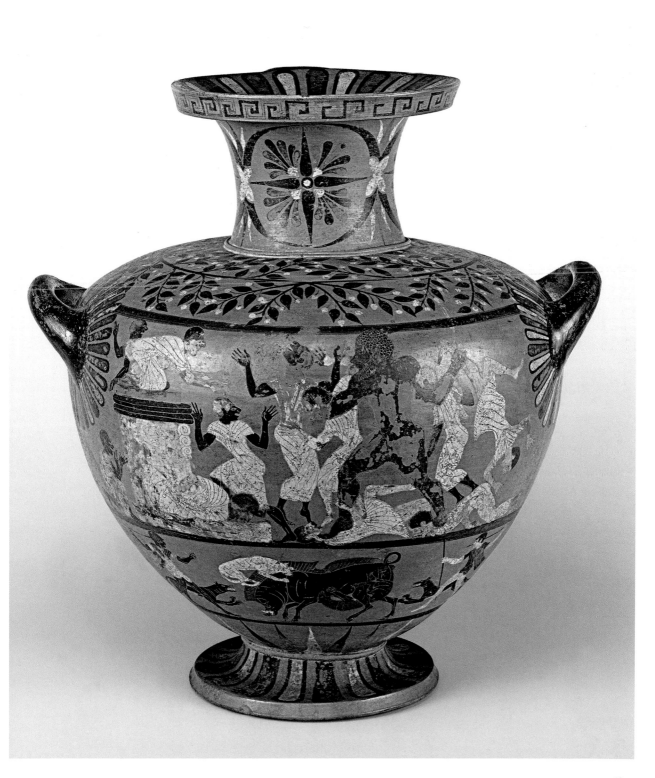

The Abduction of the Body of Sarpedon

Goblet krater, clay, height 45.8 cm, capacity app. 45 litres
New York, The Metropolitan Museum of Art

Euphronios proved his mastery as an exceptional vase painter and perfect potter over several decades. He was probably born around 535 BCE and died around 470 BCE, thus this artist experienced one of the most turbulent and exciting times. He witnessed the fall of tyrannical rule in Athens inaugurated by Peisistratus (c. 600 – 527 BCE) and the banishment of Peisistratus' son Hipparchus in 510 BCE. He was there for the birth of democracy under Cleisthenes as well as for the battle against the Persians near Marathon in 490 BCE. Ten years later he witnessed Athens' destruction by the Persians and also the victory of the Athenian fleet near Salamis that same year. Euphronios' signature has been known on different vases since 1838, both as a painter and a potter of these often underestimated clay artworks. Euphronios and some of his colleagues led the so-called red-figure technique invented in c. 530 BCE to its first major blossoming. The goblet krater in New York is undoubtedly amongst his masterpieces. It was potted by Euxitheos, as can be seen by the signature "Euxitheos epoiesen" (Euxitheos made this). Euphronios signed it on the top right with "Euphronios egraphsen" (Euphronios painted this).

The broad, artfully worked picture composition on the body of the vessel is shown in an almost ideal manner. The ornament bands of palmette leaves at the top and a sequence of palmette leaves and lotus flowers at the bottom capture the touching and grandiose scene composed in a v-shape on the battlefield outside of Troy like a picture frame (Iliad, 16,

Proto-Panaitios, drinking bowl (Kylix) with a smith, c. 500 BCE

666 – 675): the naked body of Zeus' son Sarpedon, killed in battle by Patroclus, is depicted being flown away by the two figures of Hypnos and Thanatos, Sleep and Death, to his home in Lycia. This is how he was meant to be spared the voraciousness of the wild dogs and vultures. The psychopomp and messenger of the gods, Hermes, who is overseeing the translation, can be recognized by his winged boots, his petasos or travelling hat, and the caduceus or kerykeion, his winged staff. On the left and right are two armed Trojan warriors standing impassively – evidently as mortals they are not able to see the actions of the godlike creatures in front of them. Just like the others depicted, they too are named: Leodamas and Hippolytus.

The giant body of Sarpedon dominates the picture. Blood is flooding out of the wounds to the left; the group is thus moving away to the right from the scene of the event. The hero's face, not disfigured by battle and death, isframed by long, below-the-shoulder hair, held together by a band; the similarity to the careful hairstyles of archaic "kouroi" is evident. The fine internal paintings on the wings or armour, the careful attention paid to anatomical details and foreshortening, as well as the confident use of different colour tones – from the red of Sarpedon's blood and hair to the deep black of the warriors' hair – show Euphronios' mastery. Thus it seems strange today that he came to focus completely on pottery around 500 BCE and no longer signed as a painter. However, the "cerameus", the potter, who owned his own workshop and had more financial means available, was held in noticeably higher esteem than a vase painter. Thus, Euphronios' step to self-employment surely also meant a rise in Athenian society.

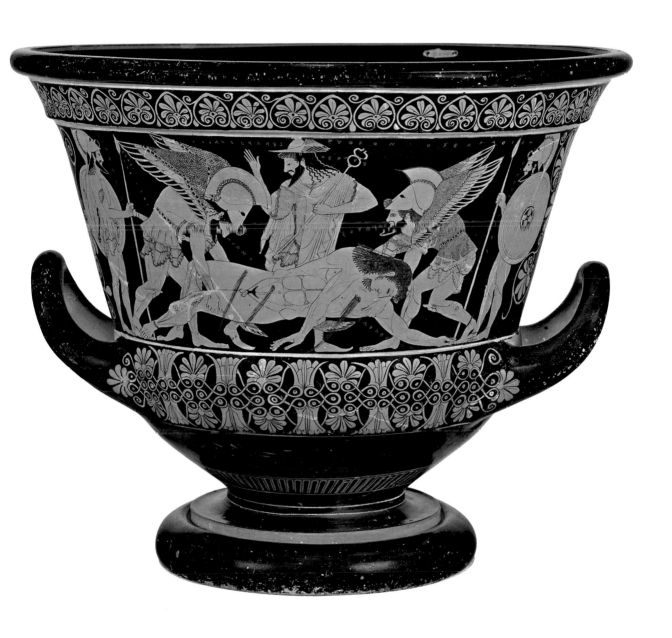

Archer from the west pediment of the Temple of Aphaea, so-called Paris

Marble, height 1.04 m
Munich, Staatliche Antikensammlung und Glyptothek

The pediment sculptures of the Temple of Aphaea discovered on the Greek island of Aegina in 1811 have been the pride of the Munich Glyptothek since their acquisition by the Bavarian crown prince and the later King Ludwig I. They are a unique testimony to the transition of Greek art from the archaic to the classical period at the threshold of the 5th century BCE. The subject of the representations in the pediments on both the east and the west side of the Doric temple is battles between Greeks and Trojans. In the left half of the west pediment, in the centre of which the goddess Athene is standing, an archer is kneeling. It is Paris, the son of the Trojan king Priam and the kidnapper of the beautiful Helen. Kneeling on his right knee, he is drawing his bow and aiming at his enemy in the left corner; the position of his arms shows that Paris was holding the bow with his outstretched left hand and was positioning the arrow with his right. He is wearing tight trousers that allow us to guess at his leg muscles. Above it one can recognize a waistcoat with a small décolleté. His head is covered by a Scythian cap, whose cheek-flaps are tied up at the back of his head.

The marble sculpture owes the sudden growth in its fame to the latest research on ancient polychromy, which is likely to revolutionize our concept of ancient Greek art. Traces of colour on the sculptures were already noted by the excavators in 1811. For that reason there were already early attempts to reconstruct the original colouring of the figures. But only the application of scientific methods and the most modern equipment have made the exact analysis of colours and knowledge of the original painting possible. The results were realized on a marble-resin cast of the archer who has become a positive icon of modern polychromy research in recent years (ill. p. 25). Over his trousers Paris is wearing another tight-fitting item of clothing that is covered in complicated diamond-shaped systems whose colours unfold into a pyrotechnic display of blue, red, green, brown, and ochre just like his trousers. The diamond network adapts surprisingly naturalistically to the stretching of the arm and leg muscles caused by the

drawing of the bow and by Paris kneeling down. The border of the waistcoat, that is evidently meant to be leather, is decorated by a hem of castellated meanders and square picture fields, in which the motif of a lion has been verified. The doublet has been shown to be decorated with depictions of a lion and an attacking griffin less than two centimetres across. The hat is decorated with a seven-leaved palmette. The bow, arrows, quiver, and the curls of hair, worked in lead, were also added. Strictly speaking the colouring of the sculpture was crucial for the identification, by the onlooker standing at the foot of the temple, of the figures and their roles in the picture programme: Paris embodied in his very colourful dress the world of the Orient, while the Greek archer on the other side of the pediment was wearing armour over a thin undergarment; on the one hand, the shimmering ornament of small diamond-shapes, while on the other hand the Greek has traces of a classically constructed meander pattern that has a calming effect. Every onlooker at the foot of the temple was thus quickly able to recognize that Greeks were fighting Orientals up there. East against west. And if they wanted they could also read into it a symbol of the long-standing enmity between the Greeks and the Persians, the struggle for freedom and democracy against an absolutist monarchy.

> "The original colours are often still to be found in areas protected from wear or erosion on the objects. Our knowledge of the colours, which were applied in the diverse ages, is in the meantime very accurate."
>
> Vinzenz Brinkmann, 2005

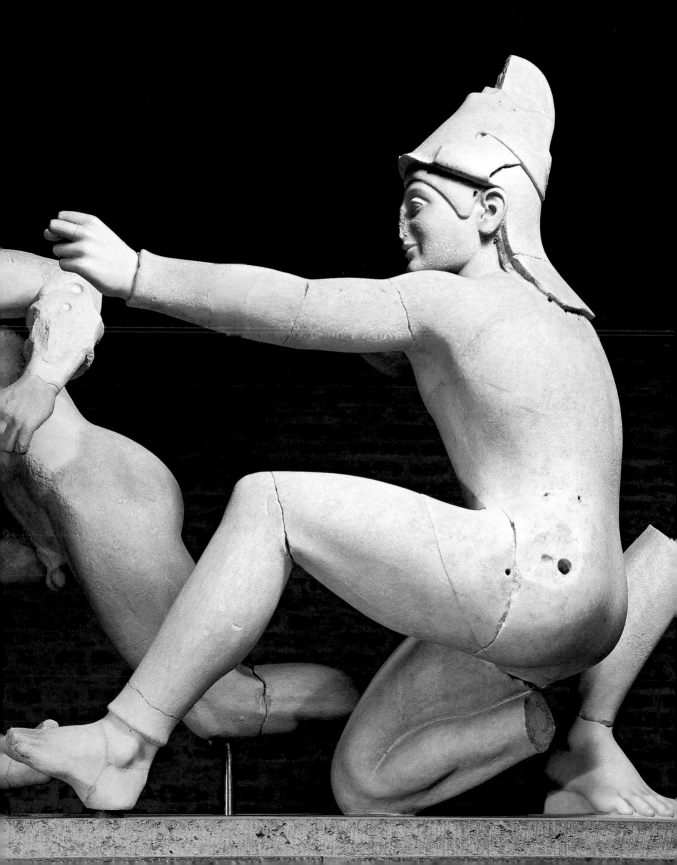

statue of an Athlete, so-called Kritios Boy

Marble, height 1.17 m
Athens, Acropolis Museum

This statue of a young athlete is the earliest surviving representation of the new image of the human being in the Greek art of the 5th century BCE. It was found on the Acropolis in Athens, in the so-called "Perserschutt" or Persian debris. This is the label given by archaeologists to the mass of sculptures on the Acropolis directly associated with the destruction wrought by the Persians during their occupation in 480 and 479 BCE. After the victory over the arch-enemy in the naval battle of Salamis and shortly after at Plataea – thus the long-standing opinion – the rubble of destroyed buildings and damaged votive gifts were solemnly buried in the course of the clean-up work. This was because items dedicated to the gods were not allowed to be removed from the sacred place. However, it has since come to light that the "Perserschutt" levelling should be seen as a large-scale levelling that immediately preceded the construction of the Parthenon, i.e. only in the mid-5th century BCE. Even if the *Kritios Boy* – thus known because he was formerly believed to be the work of the sculptor Kritios – was only buried decades after the destruction by the Persians, a dating in the second decade of the 5th century BCE is plausible.

As was already demonstrated by the images of men of the geometric and archaic periods, the *Kritios Boy* also shows the ideal of ability to move and the thus necessary functional aptitude of body and limbs. However, there is one crucial difference in the visual representation: for the first time in the history of Greek art the human body's ability to move is depicted in a visually obvious way – with all the consequences for the design. On the threshold of the Classical era, a sculptor would still avoid sharp breaks in the modelling of the body shapes – the torso's mid-line still ran vertically as was the case with the archaic "kouroi" – which consequently caused strict attention to be paid to the horizontal and vertical for the area between the shoulders and waist; and also the two arms hang parallel at the side of the body. What is new about this excellently worked statue is that the *Kritios Boy* is bearing the weight of his body on his left leg, while the other is resting on the ground bearing no weight and set slightly forwards in order to ensure his stability. This taking and not-taking the weight can be clearly seen in the left hip, which is pulled up somewhat. This standing motif is generally termed "ponderation" or "contrapost". Thus the characteristic standing motif of the Classical era with the weight-bearing supporting leg and the non-weight-bearing free leg becomes manifest – even though it is here still quite reticent. In addition the head with its fashionably short athlete hairstyle, which had by now replaced the long-haired head of curls of the 6th century BCE is no longer looking straight ahead but is slightly inclined to the right. This sideways look was doubtless reinforced by the inserted eyes made of another material. The downright revolutionary innovation of the development of ponderation had now become irreversible. Since this differentiation – which we now take for granted – between the supporting and the free leg with its organic manoeuvrability and the consequent interrelation of the body parts of humans and animals, became and remained the basis of European visual arts right up until the 20th century.

"we love beauty, but we do not become excessive; we love wisdom, but we do not become slack."

Thucydides II 40

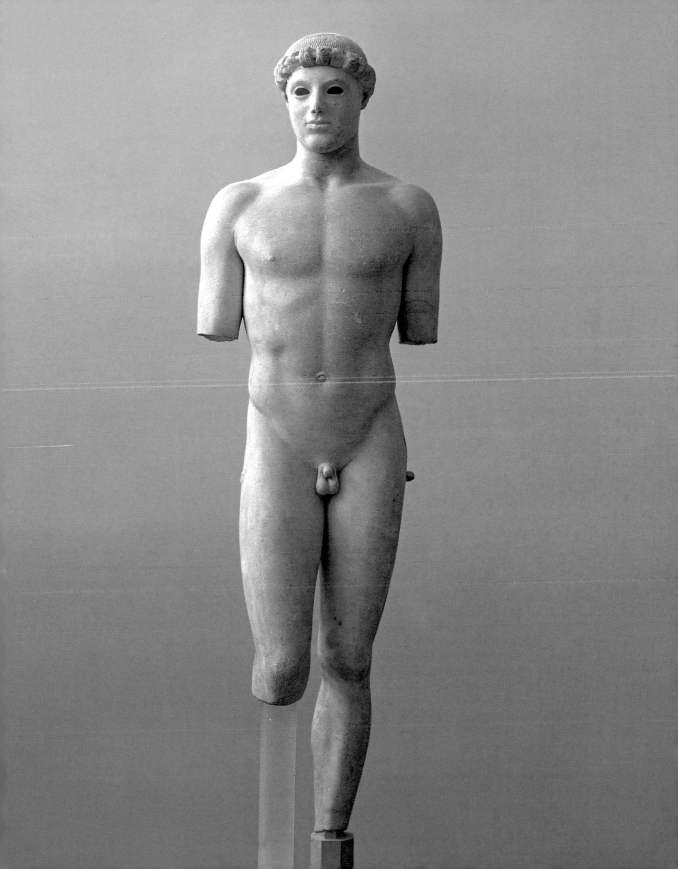

Group with the Tyrannicides Harmodius and Aristogeiton

Marble, height 1.83 and 1.85 m
Naples, Museo Archeologico Nazionale

This momentous bloody deed took place during the great festival of the city's patron goddess Athene, at the Panathenaic Games of the year 514 BCE. Aristogeiton and his younger friend Harmodius wanted to kill Hippias and Hipparchus, the city's two tyrants. Their motive was of a purely personal nature. Hipparchus died in the assault, Hippias on the other hand survived. Harmodius was killed immediately while Aristogeiton attempted to flee. He too was finally caught and put to death. Hippias, son of the tyrant Peisistratus, was able to stay in power for a few years but in 510 BCE the last of the Peisistratus family was banished. At the same time the Athenians glorified the deed committed by the two friends four years back, seeing it as a politically motivated act of liberation – the overture to the city's democratic constitution, so to speak. The famous sculptor Antenor was commissioned with the creation of a statue group to immortalize the two tyrannicides and their deed. Already by the year 510/509 BCE the work was set up on the Agora, the market square below the Acropolis. Something that was taken for granted in later ages as part of the political self-representation of the powerful had not existed until then: this was the first political monument set up for two Athenians without any religious background; speaking for itself it served as an example for the citizens and those with political responsibility in the city. The statue group was considered such a symbol for freedom and democracy that the Persian king Xerxes I took it with him after his capture of Athens in 480 BCE. The Athenians however, commissioned the sculptors Kritios and Nesiotes to create a new tyrannicides group after their victory over the Persians; this was also set up on the Agora in 477/76 BCE. It is this second group made of bronze that has come down to us via Roman marble copies.

We are no more able to reconstruct what the work of Antenor looked like than to answer the question of how far Kritios and Nesiotes tried to recreate the group taken away to Persia. The visual realization of the tyrannicide in the surviving copy does not reflect the reality as it was handed down, according to which the two hid their weapons under their garments. The depiction of Aristogeiton and Harmodius as naked, rather, elevates the events to a heroic, timeless sphere. While Harmodius is angrily waving his arm above his head in order to strike with his sword, Aristogeiton is already holding his sword ready for the blow in his stretched right hand, while the cloak hanging from his arm seems like a shield with which he wants to protect his young friend. Thus the calmly resolute older man is distinguished from the turbulent younger one, not just through their facial expressions but in their respective actions too. A thick beard on Aristogeiton is absent on Harmodius, who is shown with thick curls. All that can be seen is a hint of growth in front of the ear – often a motif used to mark heroes or young gods – and to many Harmodius must have appeared as just such a hero. Despite all the energy radiating from the group it is not the frozen moment of a dramatic action. It rather reflects the seriousness of the decision of the two for their plan and illustrates the physical strength that gave them the confidence to risk the attack.

"The delicate contour effect, which we have to assume for the late-Archaic group, is replaced by concentrated action of not just narrative impact, but an impact symbolized by the spirit of the action: a succinct drama is enacted, an Aeschylean pas-de-deux. The two friends who used the Panathenaic Games for their murderous deed are shown without festive clothes, in an over-life-sized format, and above all, are also elevated in the performance of an over-life-sized act."

Ernst Buschor, 1947

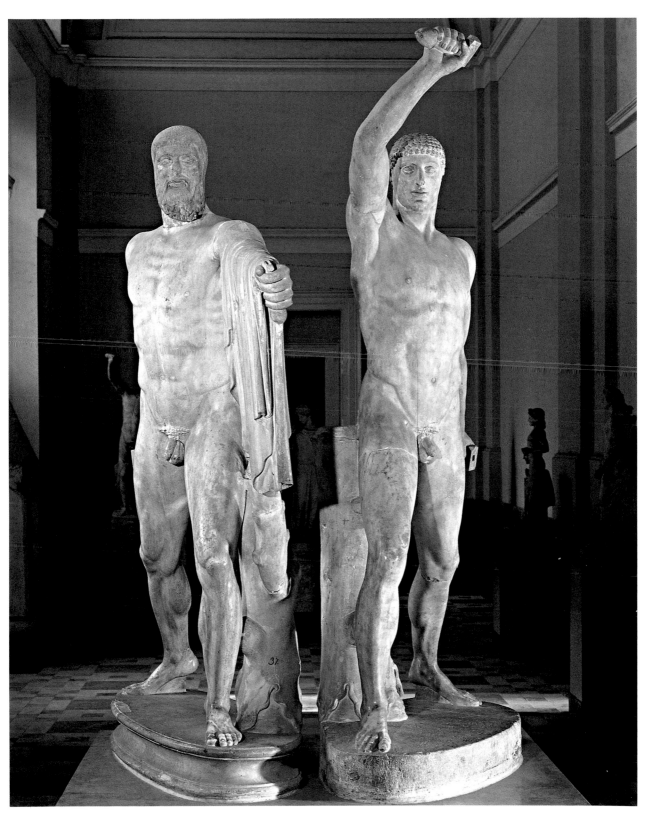

The charioteer of Delphi

Bronze, height 1.80 m
Delphi, Archaeological Museum

Today's rich, beautiful, and powerful still meet at Ascot or Aachen for example in order to admire the best and fastest horses in the world. Anyone who wanted to be anyone in equestrian sports in ancient Greece came to the famous games in Olympia; but races also took place in Delphi and elsewhere. The same was true then as it is today: only those who had sufficient financial means and thus possessed the right horses and could invest in their training could hope for a victory in the race. The royal discipline, the Formula One of Antiquity as it were, was the four-in-hand, or quadriga. An idea of the toughness and danger of this discipline may be had from the famous chariot-racing sequence in the film "Ben Hur". The crowning moment in the life of a chariot-horse owner was doubtless a victory in the hippodrome of Olympia. Whoever gained the olive branch there was entered into the list of victors and thus in a sense became immortal. In addition he was also allowed to set up a monument in honour of his victory, out of his own pocket. As a victor one could also order a victory song from one of the great poets such as Pindar (c. 522 – 446 BCE), who would then compose an ode in which he praised his client's victory to the skies. Strictly speaking the lucky individual did not even need to have any idea about how to steer a quadriga around the racetrack, as it was not the charioteer but the owner of the victorious team of horses who was at the receiving end of the ode. This fact seems just as strange to us as the fact that all Greek sports disciplines only had one victor – there was no second or third place.

The Charioteer of Delphi, side-view of the head

For that reason we will never find out the name of the charioteer whose effigy was found in Delphi in 1896. The fame of the unknown man is understandable, because at the time of its discovery there was no other life-sized original Greek bronze statue. As so often, the charioteer was only a part of a larger ensemble dedicated to the temple to which people came from all around the world to learn the future from the ambiguous prophecies of Pythia. Originally the youth was standing on the chariot platform on a stone base in his quadriga. He wore a band decorated with a meander in his finely engraved hair, and he had one or two other horses and their grooms in attendance. A block of the base was found next to the charioteer, the left arm of an "ephebos", i.e. a boy, three horse hooves, as well as one horse-tail. The charioteer stood calmly in his chariot with a look of concentration. He seemed almost pillar-like because of the uniform draping of the vertical creases in his garment. A ribbon around the body protected the chiton against the airstream. Even so, the charioteer did not stand still. Rather, one can see a slight movement that continues from the left, slightly turned foot to the equally slightly turned head. The apparent disproportion of the body is perhaps due to the original shape of the chariot, which both hid and visually balanced the overly long lower body. The charioteer gripped the reins with his right hand. It remains unclear whether he was holding anything in his left hand or whether he just supported himself with it. According to the inscription the monument was dedicated by Polyzalus, tyrant of Gela in Sicily, whose quadriga was victorious in the Pythian Games in 478 or 474 BCE. However, Polyzalus could not enjoy it for too long, because some ten years later he was overthrown.

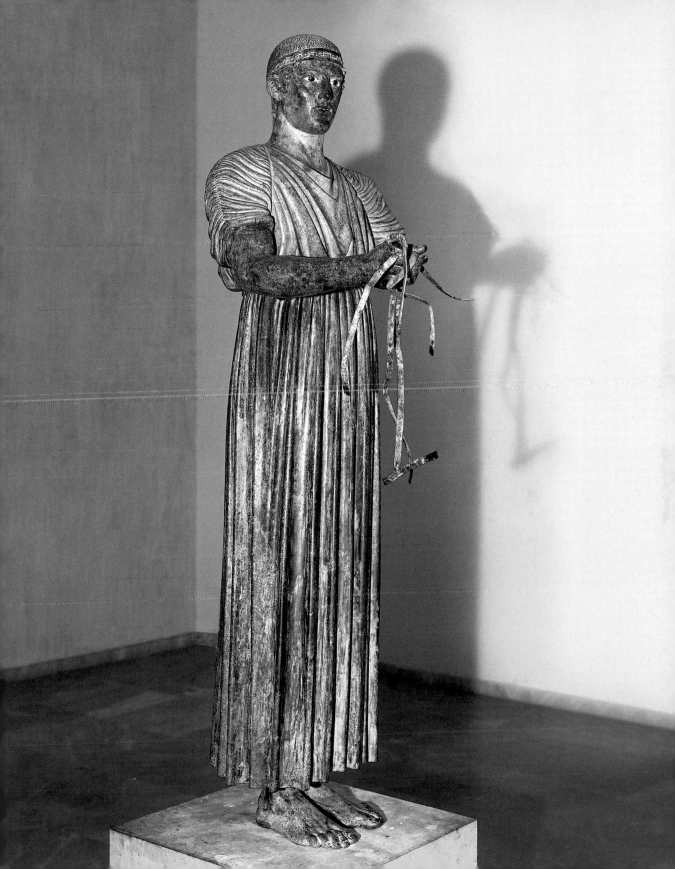

Portrait of Themistocles

Marble, height 50 cm
Ostia, Museo Ostiense

Themistocles (c. 524–459 BCE) was amongst the most significant Athenian politicians of his day. After the battle of Marathon in 490 BCE he became the heart and brain of the Greeks' defensive battle against the Persians, which culminated in the destruction of the Persian fleet in the strait near the island of Salamis in 480 BCE. However, the hero of Salamis was overtaken by the typical fate prepared by Attic democracy for anyone who appeared to the people to be too powerful: Themistocles was banished by ostracism (from "ostrakon", a potsherd, used as a voting chip). He initially went to Argos, but had to flee from there to escape execution. An irony of fate then brought him to the court of the Persian king, who amicably took in his former enemy and gave him the rule over the city of Magnesia on the west coast of Asia Minor, where he died in 459 BCE.

It is reasonable to believe that this hero who was later banished received special honours even while he was alive, not least in the form of a statue, or that he himself – this first radical politician of the still young democracy – had an effigy of himself set up. However, it was only in 1939 that a herm bust naming the one depicted as Themistocles was discovered. The slight turn of the head to the left, the consequent tension of the neck muscles, as well as the slight lowering of the right shoulder, indicate that the lost original was a free-standing bronze statue set up in honour of the hero of Salamis while he was still alive. It shows him in contrapost – i.e. with a supporting and a free leg – but whether he is naked or in armour cannot be said. The significance of the head for the creation of a Greek portrait can hardly be overestimated. Until this discovery, because of cultural historical considerations, conventional opinion was that portraits with individual traits had not existed until the 4th century BCE. This now had to be revised by a good 150 years. There is no doubt that the Themistocles portrait shows physiognomic details in a way that had not been customary in the visual arts before. It signals a clear turning away from the "idealistic" characteristics of the Archaic era, as with the "kouros" and "kore" types. The broad head with short, curly hair resembling a cap shows strong facial traits under the strongly convex, wrinkled forehead. Together with the fleshy lips under a thick full beard and the no less fleshy-looking ears, squashed-looking, like those of a heavy athlete, these details give the effigy a bulky, self-confident character. These innovations in portrait art, sensed as realistic or at least as individualizing elements, could definitely be reconciled with the traditional self-image of Themistocles. He was considered very self-centred and wanted to stand out from the crowd. It can hardly be doubted that his portrait served his own self-staging. However, whether the traits we have mentioned really corresponded to his actual physiognomy or whether the client only cared about setting himself apart from what had existed hitherto, we can no longer say. Perhaps he used this blatant deviation from the "normal type" in order to call attention to his extraordinary achievements for democracy.

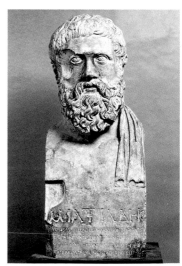

Bust of Miltiades, 5th century BCE

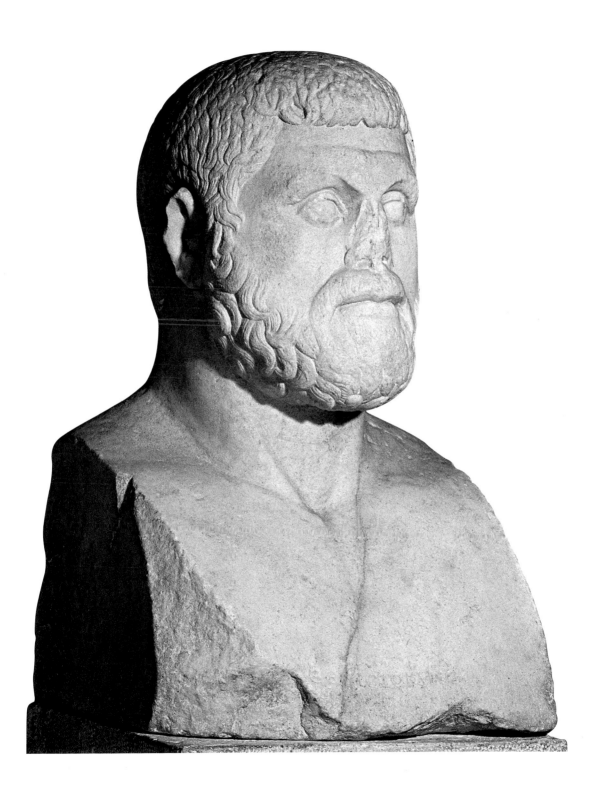

Image of Homer

Marble, height 39.7 cm
Munich, Staatliche Antikensammlungen und Glyptothek

==

"Homerus caecus fuisse dicitur" (Homer is said to have been blind). This is the only statement about the appearance of the great Greek poet that has come down to us, and even the indication of blindness is uncertain. When exactly Homer lived, where he was born – all that was already forgotten in Antiquity. Several cities wanted to claim him as their son. However, it is reasonably certain that Greek Ionia, modern-day Turkey's west coast, must have been his birthplace or at least his home. Homer became immortal through the "Iliad", the epic he wrote down in 15,693 hexameters in around 730/20 BCE. With it he created the first piece of Western literature. Until then singers had recited and passed on the story orally. It tells the story of the wrath of the Greek hero Achilles outside of the walls of Troy. Here, Greeks and Trojans were fighting a ten-year war over the beautiful Helen, kidnapped from Sparta by the Trojan prince Paris. Troy only fell when Odysseus thought of the cunning trick of the Wooden Horse. The Trojans took it into their city, not suspecting that Greek warriors were hiding inside, waiting for nightfall so they could climb out and destroy the city. To this day the myth of Troy has lost none of its fascination, neither in art, nor in literature, nor in the modern mass media; one need only think of Christa Wolf's "Kassandra" or Wolfgang Petersen's screen spectacle "Troy".

Of course the Greeks wanted to create an image of the poet who wrote down their national epic. However, because Homer had lived in the second half of the 8th century BCE, i.e. in the geometric era, and thus no representations with facial features could be handed down, artists had to rely on the creation of an imaginary portrait of their master poet. The oldest of these fantasy images was probably created around 460 BCE. Six Roman copies are known of the lost original bronze statue. The head in Munich is qualitatively the best. It depicts an older man with a full beard and half-closed eyelids. Just as the beard says less about the age of the one depicted than of his dignified status, so the closed eyes are a symbol of blindness, but they do not refer to a physical handicap, but, as in all cultures, also the special ability of a singer or a poet to remember the past and cast a visionary eye into the future. Homer has thick hair held by a thin beaded band that covers the ears and reaches to the nape of his neck. As was the ancient fashion, two long strands of hair are combed to the front and tied together above the forehead. The long-stranded full beard appears somewhat block-life and stiff. Clear forehead wrinkles, loose cheeks, deep eyes with crow's feet, and well-developed wrinkles next to the nose impressively characterize the singer in old age. The iconography of the once over-life-sized bronze statue is unknown. Perhaps Homer was supporting himself on staff and wore a cloak, as another statue shows him. It is also reasonable to think he was portrayed with a lyre, the instrument of the Homeric singer. The patron, the location where it was set up, and the function of the artwork, which was doubtless quite famous, also remain unknown. It may be that a city wanting to be considered Homer's home honoured its great son posthumously with a bronze statue.

"Two singers complete the picture of the protagonists. First the lost bronze statue of the blind singer Homer, who is striding along to the sound of the lyre and thereby remains in the tradition of the older images of a poet. The Munich copy shows us the godlike old man's head in the purest way: turned towards us, inwardly listening and looking. In the portrait created in around 460, this bearer of fate is turned further in upon himself; the gaze of the bronze-sculptor encounters the poetic nature of the man he is depicting in touching harmony and uncovers profound possibilities of portraying his inner being."
Ernst Buschor, 1947

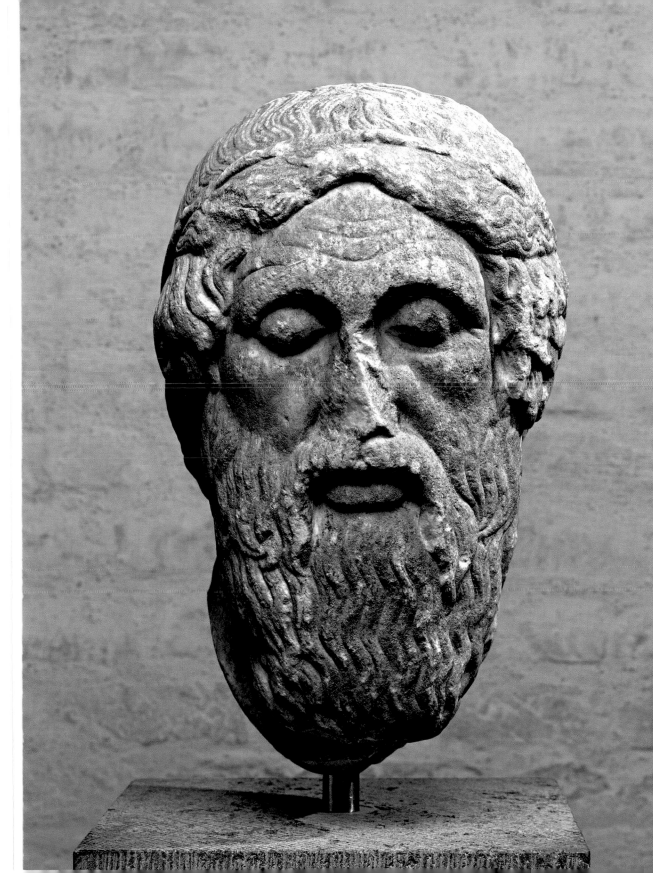

Poseidon, Apollo, and Artemis on the Parthenon's East Frieze

Plate VI, marble, height 1.06 m
Athens, Acropolis Museum

For around 2,500 years it has been the landmark of the city of Athens and also the most impressive monument that Attic democracy erected for itself: the Parthenon. This temple, begun in 448 BCE and completed in 432 BCE on Athens' Acropolis, was the vault for the treasure kept there by the Delian League under Athenian supremacy and also a shrine for the gold and ivory effigy of the goddess Athene. Of course the architects Ictinus and Callicrates did not construct a marble building that complied with the canonical rules of the so-called Doric order. Athens showed the ancient world what kind of architectural and artistic accomplishments the only superpower in Greece besides Sparta was capable of. Instead of the usual number of columns surrounding the cella – six across and thirteen along – they increased the numbers to eight and seventeen – seemingly a triviality, but for the accepted order of Greek architecture it was revolutionary. In addition the architects planned a more than 160-metre-long figure frieze for this Doric temple to decorate the outside of the cella. The frieze was a characteristic element of the Ionic order. Thus it was the first time the two classical orders merged: innovation or arrogance? The frieze – the majority of the slabs were taken by Lord Elgin at the start of the 19th century to London, where they still are, together with other parts of the Parthenon, the pride of the British Museum – depicted the Athenians' sacrificial procession during the celebration of the Panathenaic Games that took place every two years. It was a demonstration by the powerful democracy in the presence of the Olympian gods. The narrative related on the frieze's slabs begins on the West side with the preparations for the procession, while the two long sides show the procession with its participants.

It is almost unbelievable how three and more relief layers a few centimetres behind one another create an uncanny perspective. Horses and charioteers are jostling, sacrificial animals are being hurried on, and worthy citizens, girls, and youths are converging to their destination in the procession: the Acropolis and the Parthenon, where Athene was handed the newly woven "peplos". The gods depicted on the East side of the cella are sitting relaxed on comfortable stools, some of them absorbed in conversation waiting for the procession. In the scene shown here the youthful, beardless Apollo is turning to Poseidon, whose head is characterized by the long, thick, heavy curls that merge into a carefully groomed beard and frame the calm expressions of the face. In his raised left arm Poseidon must have held his trident. Artemis, goddess of the hunt and sister of Apollo, is sitting in front of the two gods. Her long, curly hair is carefully tidied into a scarf. She is dreamily peering towards the "phyle" heroes, the saints, as it were, of the individual Athenian tribes. With her right hand she is holding the fine chiton on her shoulder, flowing down her torso in many folds.

Stylistically, archaeologists were able to find no less than eighty different stone masons who worked on the frieze. The quality also varies, but it is always of an extraordinary level. All the artists subordinated themselves to an overall plan, for which Phidias clearly had control, and which was doubtless subject to changes over the years. Some artists had new ideas and the discussions of the citizens also had to be taken seriously, since it was they who decided on the funding of this prestige object.

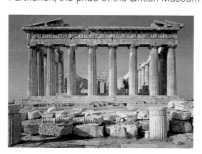

Front of the Parthenon on the Acropolis, 5th century BCE

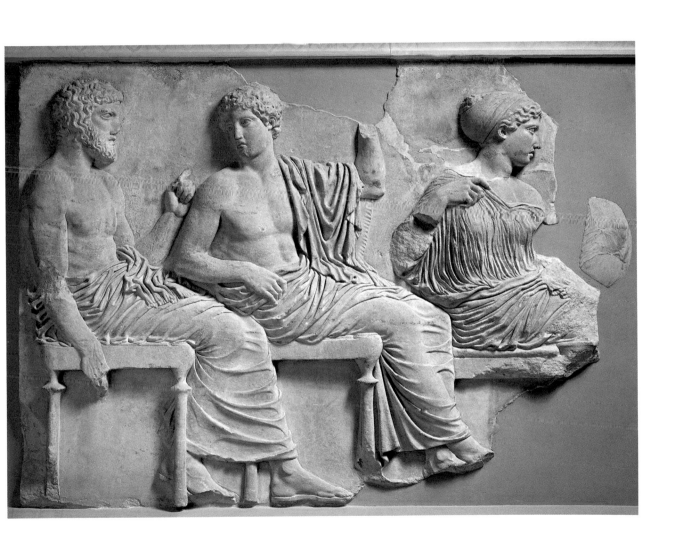

Athene Parthenos, so-called varvakeion Athene

Marble, height 1.05 m
Athens, National Archaeological Museum

Everyone who saw her in the interior of her temple on the Acropolis of Athens must have been incredibly impressed by the sight of this artwork, regardless of whether they were a stranger in the city or had to suffer under her superpower ambitions. The effigy of the goddess *Athene Parthenos* was something special, it was unique. The representation of Athens' patron goddess was around 12.5 metres tall and made of gold and ivory. It was a masterpiece by Phidias (active c. 460 – 430 BCE), as the ancient sources report. The gold used for the surface of the statue is said to have weighed around 44 talents, which corresponds to a weight of around 1.14 tonnes. The gold plates were attached to a wooden frame on the inside of the statue and could be removed at any time. Face, hands, feet, and all the other naked areas of skin were carved out of ivory. Other materials, such as bronze or semi-precious stones, must have also contributed to its magnificence. A more detailed description of the goddess's effigy, which was created between 448 and 438 BCE, was composed by the Greek traveller Pausanias in the 2nd century CE after his visit to Athens. Athene was wearing a "peplos" and around her neck the "aegis", bearing the head of the Gorgon. Her helmet was crowned by winged horses, stags and deer. On the ear plates could be seen rearing griffins. In her right hand, which must have been resting on a column, she is holding the statue of Nike, the victory goddess. Her left arm was holding a shield on the inside of which a serpent with a raised head is stretching out to the beholders. At several places could be seen reliefs showing numerous figures. On the front of the plinth could be seen the birth of Pandora. On the sides of the base was a fight with centaurs – creatures who were half human and half horse. The inside of the shield shows the fight of the gods and the giants, its outside was reserved for the battle between the Athenians and the Amazons. Precisely because no remains of this colossal work have survived, this description and a few other written testimonies are of great significance in order to identify the few reproductions of the lost cult image in the surviving inventory of monuments.

These pieces can of course never be exact copies, since their smaller format and the materials used can only bring across a very incomplete impression of the original. The marble statuette shown here is among those copies that allow a particularly good idea of the whole, even though the small size – it measures with its height of one metre just a twelfth of the original – forced the sculptor to do without the depiction of the relief images and simplified various other details. However, despite the small format, the *Varvakeion Athene* still brings across some of the monumentality of the lost original. The *Athene Parthenos* itself soon became an icon of the classical period. Thus it is not surprising that a 3.10-metre-high marble statue of the *Athene Parthenos* was set up in the library of Pergamon in the 2nd century BCE. Now the statue was no longer a cult image but a monument with which the kings of Pergamon expressed their reverence towards Athens' art and science, of which they considered themselves the keepers and sustainers.

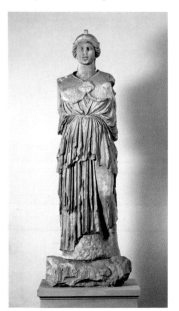

Statue of Athene Parthenos, 1st half of the 2nd century BCE

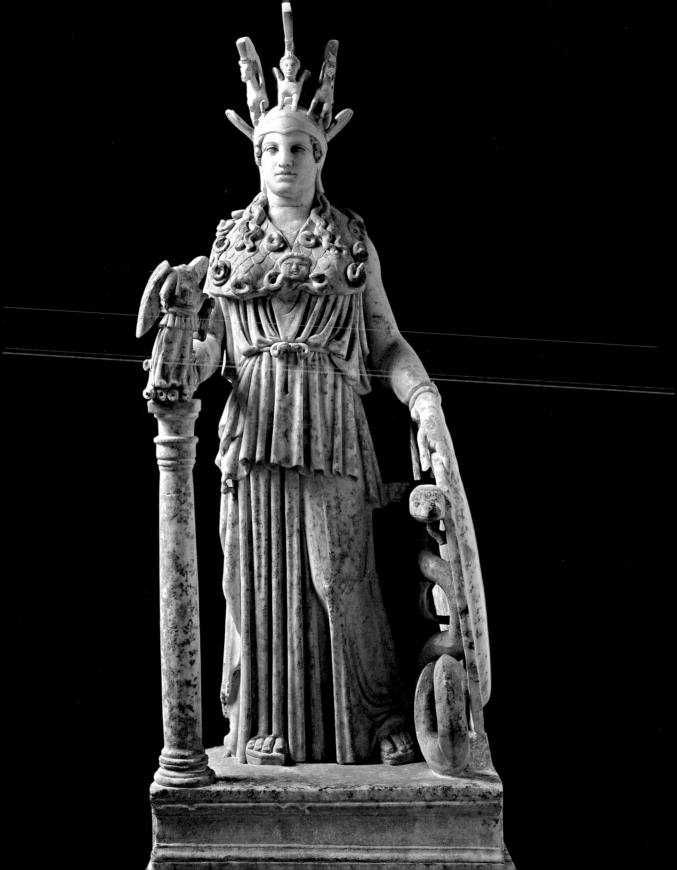

wounded Amazon (sciarra type)

Marble, height 1.83 m

Berlin, Staatliche Museen zu Berlin – Preussischer Kulturbesitz, Antikensammlung

The "agonal principle" was a characteristic of Greek culture. This enthusiasm for competition was by no means only limited to athletic competitions in Olympia and other places. The desire for "agon" pervaded almost all areas of life. Thus it was not just runners or boxers who fought for the victory wreath, but also tragic and comic poets, singers and visual artists. Pliny the Elder (23 – 79 CE) wrote about such a contest between the most famous artists of their time in his Natural History (Naturalis historia 34, 53). According to this testimony five sculptors, including Polycleitus, Phidias, and Cresilas, were commissioned by the Temple of Artemis in Ephesus to create a statue of a wounded Amazon. Then they were supposed to settle amongst themselves which work was the best. Polycleitus was unanimously proclaimed the winner.

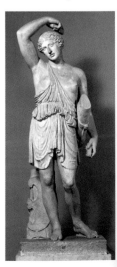

In the surviving monument inventory there are several Roman-age copies of three types of statues from the high Classical period that show an Amazon, wounded in battle, supporting herself, with no opponent present. They are thought to be repetitions of three lost bronze originals in Ephesus. Scholars ascribe the "Mattei type" to Phidias, but they are not sure about the "Sciarra" and the "Sosicles" types – which one was created by Polycleitus and which one by Cresilas? All three are approximately 1.86 metres tall and are wearing the short Greek men's chiton. The pinned-up hair resembles the long hairstyles of high-status Greek women and the exposed, fit bodies resembles those of the male warriors and athletes. The marble copy of the "Sciarra type" in Berlin shows the warrior standing on her right leg. Her left leg, slightly bent, is only resting lightly on its toes. She has brought her right, raised arm to her head, which then draws attention to the wound under her armpit. She is supporting herself on a column with her left arm. The Amazons in Ephesus were the first three-dimensional figures to be shown supporting themselves thus, and particularly the "Sciarra type" stands at the beginning of a long line of sculptures with this motif. The wound was caused in a battle. The subject of Amazonomachy, the bellicose confrontation between Greeks and the women from north of the Black Sea, who are generally portrayed in Scythian dress, had been known since the 7th century BCE. Alongside the opinion that the genuinely Greek invention of Amazonomachy is a metaphor for the victory over the archenemy – the Persians – these days there is also the recognition that it reflects a social conflict. The manifest equality between men and women in the warrior society of the Amazons could therefore also be understood in the sense that the hostile warrior women were contravening Greek norms of life and thus threatened the existing social order to the utmost. The special feature of the Amazons of Ephesus, however, is their representation in Greek manner, setting them on one level with the Hellenic warriors. Their facial expressions show thoughtfulness, perhaps about their pride in wanting to do away with the valid norms, and being punished with a wound because of it. Reflexion can lead to insight and to saying no to pride. "Sophrosyne" helps defeat "hubris". Thus the statues in Ephesus possibly mark a completely new interpretation of the conventional Amazon image.

Wounded Amazon (Sosicles type)

Wounded Amazon (Mattei type)

Portrait of Pericles

Marble, height 54 cm
Berlin, Staatliche Museen zu Berlin – Preussischer Kulturbesitz, Antikensammlung

The years between the Greco-Persian wars and the start of the Peloponnesian War, i.e. between 480/79 BCE and 431 BCE, are justifiably considered Athens' political and cultural Golden Age. If the name Phidias stood for the heyday of Attic art, then the name of Pericles became synonymous with this period in the field of Athenian power politics. Like hardly anyone before and after him, he authoritatively decided the policies of his home city for many years and used its great wealth for the architectural and artistic beautification of the Acropolis. However, Pericles was also responsible for the political snubbing and neutralizing of many allies and finally led Athens into the fatal civil war with Sparta and its allies, which, in 404 BCE, signified the end of Attic democracy. His portrait has come down to us in four replicas dating from the time of the Roman Empire. Two of them are known from inscriptions. The lost original was a life-sized bronze statue.

The bust shows Pericles as a mature man. He is wearing a groomed full beard, whose curls are carefully arranged. On his head he is wearing a Corinthian helmet slightly pushed back, from under which thick hair curls are emerging. The Berlin head shows strands of hair behind the helmet's high-placed eye-holes, as do two other copies. This was seen as a clue to Pericles' over-long head, which caused him to be ridiculed as a "squill head" in contemporary Attic comedy. Even though it is said that most artists portrayed Pericles wearing such a Corinthian helmet in order to disguise this anomaly, the strand of hair on the Berlin

A seer, detail from the Temple of Zeus in Olympia, c. 470 BCE

head could have also been a learned addition by the Roman copier who knew the relevant sources. Below the well-proportioned eyebrows are equally well-proportioned lids surrounding the eyes. The mouth is slightly open. The facial expression is serious. Every emotion and every hint of individual peculiarity is missing – quite different from the older image of Themistocles (ill. p. 61). A slight turning and stretching of the head and unevenly falling shoulders on the head replicas show that the original was a statue that had a supporting and a free leg, i.e. it was set up in the "contrapost" position. It cannot be ascertained whether Pericles was portrayed naked, dressed, or in armour with chiton and breastplate.

In any case the statesman, with his superior-calm facial expression, appeared to the beholder in idealized form. This was a desired aspect of the representation. It was said of Pericles that he was distinguished by a high degree of self-control and was very capable of suppressing emotions. With this kind of self-stylizing, the politician and strategist could feel in harmony with the valid norms of how leading statesmen of his time were supposed to appear in public. The original statue must have been created while Pericles was still alive – around 430 BCE – which would support this assessment. It was probably identical to a bronze effigy of Pericles that, according to written testimony, was created by the artist Cresilas. Pausanias was still able to see this latter statue, just behind the Propylaeum of the Acropolis in Athens, i.e. in the entrance area of the sanctuary and within sight of the temple built under Pericles that is still a symbol of the classical period to this day: the Parthenon.

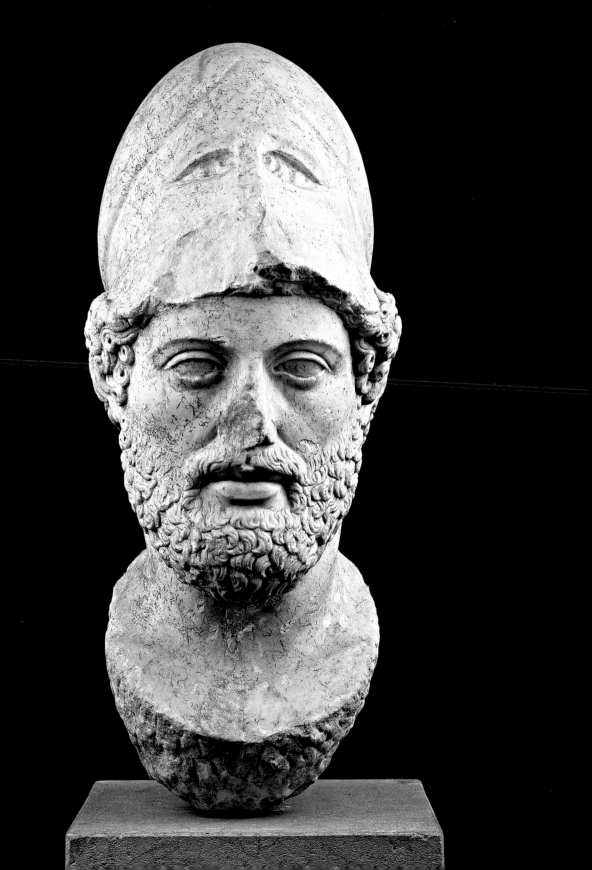

неad of zeus from olympia

Carnelian, 2.25 x 1.93 cm
Berlin, Staatliche Museen zu Berlin – Preussischer Kulturbesitz, Antikensammlung

One does not need to be a declared expert on the iconography of Greek gods to recognize that this is an image of the father-god Zeus. It is also a good example of the craftsmanship of ancient stone cutters. For the beholder must not forget that this carefully worked and almost monumental bearded head of a man was cut out of a carnelian just 2.5 by 2 centimetres in size. Serious, dignified, and perhaps a little strict the father-god is looking to his right, depicted in the classical profile with the smooth bridge between forehead and nose so popular in ancient Greece. A thickly curled beard surrounds the face. The carefully groomed hair held by an olive branch falls in three thick strands over the shoulders, similar to the archaic "kouroi".

The portrait from the 2nd quarter of the 2nd century CE surely does not show any fantasy image, rather it must have had a famous model. The olive branch in the hair provides an important clue: a branch from the holy olive tree in Olympia was the prize for the victor at the Olympic games in honour of the father god. It was in the Temple of Zeus at Olympia that one could marvel at one of the seven Wonders of the World: the *Zeus* of Phidias (active c. 460 – 430 BCE) – a monumental gold and ivory effigy like the *Athene Parthenos* by the same artist. This artwork was famous throughout the ancient world. It was considered a misfortune to die without having seen the Zeus of Olympia, and conversely it was said that nobody could still be unhappy in life if they had seen it. The good-12-metre-high effigy of the sitting Zeus was hollow on the inside. It consisted of a load-bearing wooden frame to which countless parts and shapes of gold, ivory, gemstones and other precious materials were attached. None of this magnificence has survived. All that has been found, in the workshops close to the temple, is tools, clay moulds, ivory and glass remains, obsidian pieces, and bronze and lead chippings. Coin images give us an idea of how it looked, as well as the intaglio shown here. The detailed description by Pausanias from the 2nd century CE however, is particularly valuable. The world ruler sitting on a throne of decorated ebony held a victory goddess in his right hand, while the left hand was supported on

a sceptre crowned by an eagle. His hair, crowned by an olive wreath, was gold, as were his sandals, and his garment with its inlays of figures and lilies, which did not entirely cover the body. The face, chest, arms, and legs were made of ivory. The eyes consisted of coloured stones, and the feet were resting on a high stool. All the larger surfaces were decorated with ornaments or figural scenes from the worlds of gods, heroes, and humans. Above and beyond any artistic-aesthetic appreciation, Phidias must have managed to waken awe in onlookers. Thus it is not surprising that even a more sober and rationally thinking Roman like the general Aemilius Paullus, when he looked upon the image of the god in 168 BCE, had the feeling that the ruler of Olympus was present. It was also inevitable that the Church Fathers, as the shepherds of the still young Christendom, raged against this graven image with bitter polemic. However, they were not able to dispel its fame as an artwork and as a Wonder of the World.

**Roman sestertius with the depiction
of Zeus at Olympia, 133 CE**

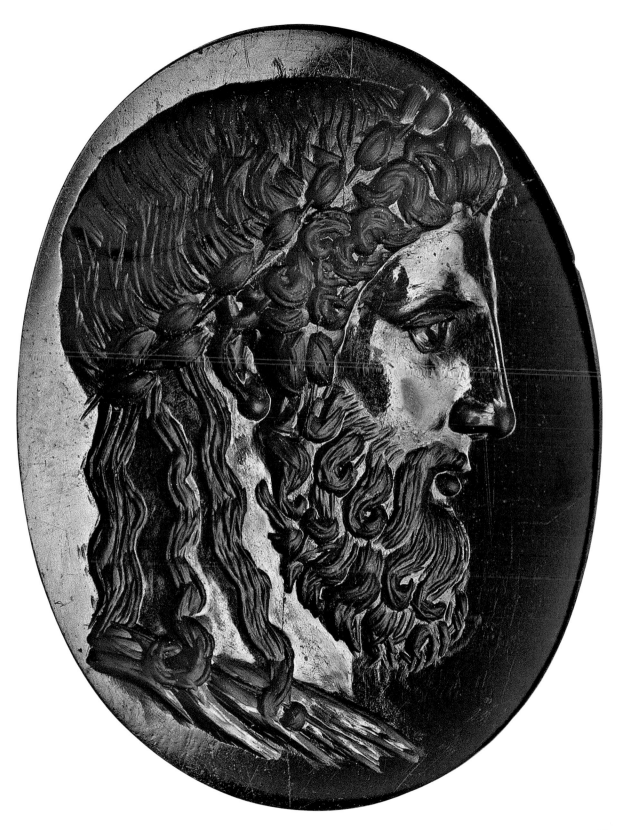

Portrait of Alexander the Great (so-called schwarzenberg Alexander)

Marble, height 35.3 cm

Munich, Staatliche Antikensammlungen und Glyptothek

There is hardly a Greek ruler who changed the map of the ancient world so lastingly as Alexander III of Macedon, known as Alexander the Great (356 – 323 BCE). During his short life he revolutionized Greece's political development and caused an internationalization of Greek thought through his conquests of previously unknown lands. Finally, he initiated a new type of ruler representation with his portrait images, which exerted a lasting influence on later generations of victorious rulers and those potentates who wanted to be seen as such. The sculptor Lysippos played a crucial role in the determination of the Alexander iconography, since he advanced to being a court sculptor with the privilege of being the only one allowed to make three-dimensional images of the ruler. The so-called *Schwarzenberg Alexander* is obviously a passed-down copy of a portrait done by Lysippos. This is all the more of a happy circumstance since this effigy was created while the king of Macedon was still alive – in contrast to numerous portraits that were only made after his death.

Numismatic portrait of Alexander the Great, silver tetradrachma, c. 300 BCE

The head serves as an example of the iconographical singularities of the Alexander portrait which allowed the world conqueror to advance from a beardless youth – shaving the face became fashionable because of him – to a lion-like manly hero in the image world of his time. The hair above the forehead forms a rising twirl termed an "anastolé" by scholars. This is one of the surest distinguishing characteristics of Alexander the Great. The striking turn of the head is another feature found in his portraits, as are the eyes gazing into the distance.

The special quality of the Schwarzenberg head lies in its subtle surface treatment. The subtle irregularities of the skull at the forehead and temples can be seen beneath the thin skin, which also covers the lean cheeks. The eyes are narrow, the forehead is broad, and above it the head of hair spreads out in stretched, lively layered curls. The lost bronze original, which was around two metres tall, probably showed Alexander the Great in a standing position, leaning on a lance. Beholders of the statue would have quickly realized that they were not looking at just any young prince or ruler, but at the victor over the Persians and the conqueror of a world empire. The symbols necessary for this appreciation could be easily read by ancient admirers: the "anastolé" shows the lion-like courage, the turn of the head suggests energetic decisiveness, his wide-open eyes gazing into the distance identify the successful visionary, who saw great deeds and victories for himself and his people on the horizon. One would have been standing in front of the incarnation of heroic appearance and the bodily ideal. However, the surviving sources paint a different picture of Alexander's appearance. Evidently he was short and light-skinned, had an oddly twisted neck, and only sparse beard growth. Thus the shaven face could certainly have been more to conceal his meagre beard growth than a consciously planned stylization of eternal youth – a divergence of reality and appearance as has been practised in visual propaganda down the ages. The ruler was portrayed in the way he wanted to be seen. Alexander valued his virtues and his masculinity.

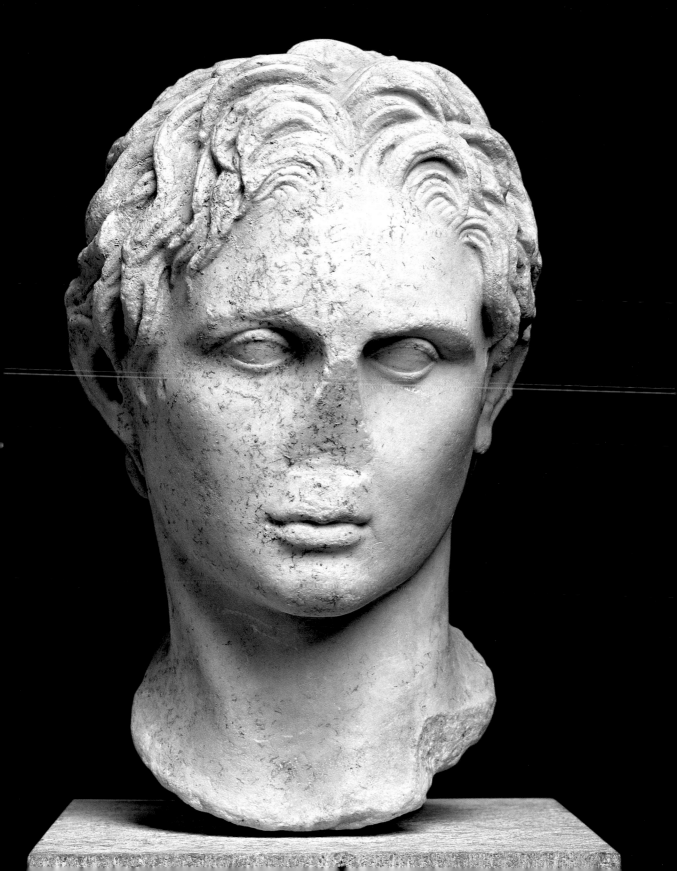

athlete cleaning himself (Apoxyomenos)

Marble, height 2.05 m
Rome, Vatican Museums

Anyone who left a great Greek sporting event as a victor had the right to have a statue erected of himself to tell posterity of his own success – provided he had enough money or rich patrons to cover the costs. It is therefore no wonder that the Temple of Zeus in Olympia, where the most famous games of Antiquity took place every four years, was overflowing with victory statues from every discipline and from many past Olympic Games. Not to mention the numerous votive gifts Zeus received from thankful individuals and victorious city states, who donated a tenth part of their spoils of war to Olympia's sacred grove, the Altis. During his visit in the 2nd century CE Pausanias still saw a whole forest of victory statues. He devoted no fewer than eighteen chapters to listing the names and disciplines of the Olympic winners. The statue shown here is also the effigy of a victorious athlete that once proclaimed the fame of the athlete named on the now lost inscription.

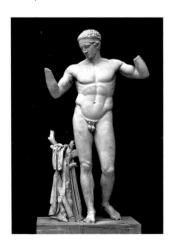

Athlete with victor's ribbon (Diadumenos), 5th century BCE

The youth is not shown in the moment of putting on the victory band, nor is he shown in a typical victory pose nor with a symbol, such as a discus. No, the artist chose to capture a moment shortly after the victory in the "palaestra", where wrestling matches took place: exhausted from the efforts of the fight, absorbed, looking into the distance, the athlete is scraping oil and sand off himself with a strigil. This marble copy, dating from Roman times, of a lost bronze original recreated a famous work by the sculptor Lysippos from Sikyon: the Apo-xyomenos, the "Scraper". The tree trunk behind the left leg and the marble support at the right thigh were not there on the original; they are necessary stabilizers for the marble, which is at risk of breaking and are not necessary for bronze casts. The *Apoxyomenos* was already so famous in Antiquity that he was transported to Rome in the reign of Emperor Augustus (27 BCE – 14 CE) and set up near the site where the Pantheon would later be built. When Tiberius (reigned 14 – 37 CE) had the statue brought into his palace's private quarters, he was openly confronted with the Romans' anger. They vented their vexation so loudly during a theatre performance that the emperor relented and had the statue exhibited publicly again. It was said of Lysippos that Polycleitus' *Doryphoros* (ill. p. 67) was the only teacher he would accept. This confrontation with the great model is also visible in his *Apoxyomenos,* even though the two works display considerable differences. These are due in part to the stance. The spear-bearer is standing in tense concentration. He is balancing his body weight and his body's twisting on one leg. He thus conclusively settles the law of contrapost, of weight-bearing and non-weight-bearing. The *Apoxyomenos* on the other hand is portrayed in a moment of movement. As a result of the action which is being carried out by the athlete, a pendulum motion of the body is created: an interaction of the free leg, taking only half the strain, and the counter-momentum of the arms, hips and torso. In addition the athlete greatly affects the beholder's environment by the extent to which he reaches out into space. This is further increased by the way he gazes into the distance. However, both statues have something in common, and this on the highest artistic level: the interplay of bodily weight distribution.

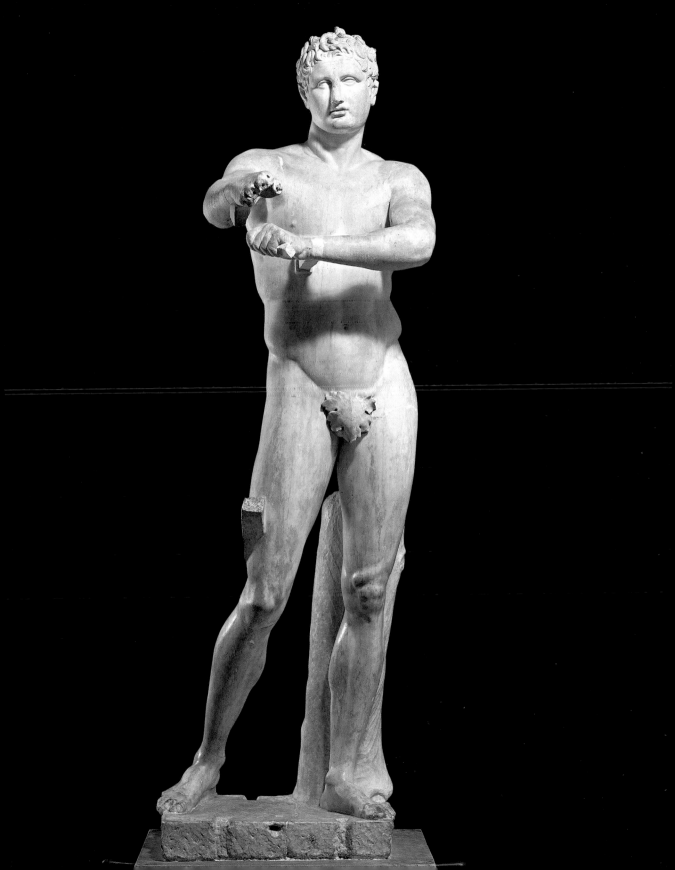

Alexander the Great forces Darius III of Persia to flee (Alexander Mosaic)

Mosaic, height 3.42 m, width 5.92 m
Naples, Museo Archeologico Nazionale

There is no doubt about it: 24 October 1831 was a lucky day for archaeology. That was when the excavators found the famous Alexander Mosaic in the great Garden Hall of the noble "Casa del Fauno" in Pompeii. This floor mosaic, assembled from a good 1.5 million small, colourful stones, imparts the best idea so far of the wealth of Greek monumental images. The model in monumental painting is revealed by the many highlights itself and also in the attempt to reproduce reflections. In addition it gives an idea of how many masterpieces on wood, plaster, canvas, and other materials are lost forever. Even the plentiful remains of Greek painting that we know from graves, grave steles, or copies for homes in the towns around Vesuvius, cannot balance this loss.

The masterfully composed scene depicts the meeting of two kings who represent two worlds: Alexander the Great and the Persian king Darius III (reigned 336 – 330 BCE). In the left half of the picture one can see Alexander on his horse Bucephalos. He is not wearing a helmet and one can see his thick hair and his famous "anastolé". He is wearing armour. The breastplate is decorated with a Gorgon and the epaulettes show bolts of lightning. His target is Darius who is standing out far above the rest in his chariot. A young Persian has thrown himself between the charging Macedonian and his master. He is being speared by Alexander's lance, which was actually meant for Darius. The artist drew the fray of battle with astonishing attention to detail and knowledge of anatomy and perspective. The detailed and filigree representation of the garments and armour is equal to the variety of the warriors' facial expressions, which are marked by death, horror, and wildness. The Persian king's charioteer has recognized the danger and is turning the chariot to flee. He does not even pay heed to his own people; one Persian tries to stem his shield, in which his face is reflected, against the big wheel – but to no avail. He will be run over in the next moment. Darius himself is not thinking of flight and is leaning far back with an outstretched arm to his companion. His horror and pain at the death of his faithful companion are written in his face. The drama of the event captures the attention of the beholder. The image's atmospheric density lives by the captivating depiction of the people and their fates, the victors and the defeated, not of an illusionistic spatial layout – a century-long tradition in Greek art. We know of no other representation in ancient art that captures the defeated in such a gripping manner. It was a great master of his craft who created this picture. For a long time the name Philoxenos of Eretria was given again and again: he is recorded as having painted an *Alexandri proelium cum Dario*. It remains unclear whether the battle depicted is the Battle of Issus of 333 BCE or the Battle of Gaugamela of 331 BCE. Recently there have been voices questioning this attribution and thus whether Philoxenos was the creator. This difference of opinion, however, changes nothing about the magnificence and the outstanding significance of the picture for Greek painting.

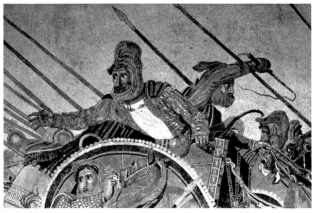

Detail of the Alexander Mosaic: Darius III, king of Persia, in his chariot

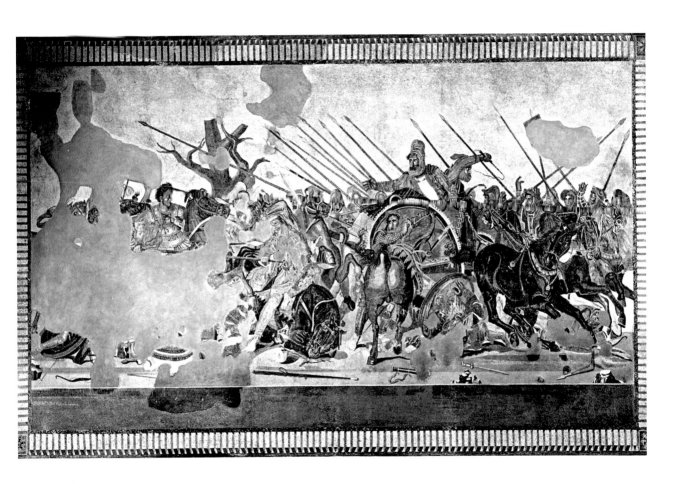

Alexander the Great or another Ptolemy as a Pharaoh

Rose granite, height 1.67 m

Frankfurt on the Main, Liebieghaus – Skulpturensammlung, property of Städelscher Museums-Verein e. V.

At first glance an Egyptian pharaoh can be recognized in this statue made of rose granite. The depicted person is wearing the characteristic royal apron and "uraeus" (cobra) headgear; the staves he originally held in his hands have been broken off. This stone could only be got in Aswan and was sacred to the sun god Amun. Unfortunately we cannot name this ruler from the land on the Nile because we do not have the corresponding hieroglyph inscription. However, some stylistic singularities in the working of the effigy prove that the statue was made by a Greek sculptor depicting a Greek king in the millennia-old Egyptian style as a Pharaoh – with the left foot forwards, lowered arms, and the obligatory back pillar. Such an effigy only became possible after Alexander the Great conquered Egypt in 332 BCE.

While the position of the Pharaoh to the left and the turn of the head to the right would be no less unusual for an ancient-Egyptian stonemason as the asymmetries in the design of the head-dress, there is one feature that definitively attests to the Greek influence: for the first time we can see a wreath of curls under the head-dress. This motif was known in the late 3rd century BCE, but the curls of this statue differ from the later ones through their greater volume and because the central curls are longer than those at the side.

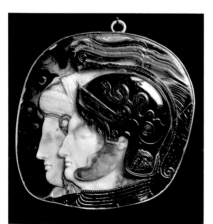

Ptolemy II Philadelphus and Arsinoe II or Alexander the Great and his mother Olympias (so-called Ptolemy Cameo), 278/269 BCE or end of the 1st century BCE

If one follows the reasoning of some specialists on Greek sculpture, then this statue depicts no less a figure than the conqueror of Egypt himself, Alexander the Great. The differently shaped forehead curls would thus be the Egyptian interpretation of the world conqueror's hairstyle with its forehead curl, the "anastolé", which made his hair resemble a lion's mane and thus indicated the lion-like courage of the Macedonian king. In that case, this ruler effigy would both be the oldest and the only original effigy of Alexander the Great. That may sound unusual at first, but from the Ptolemies to the Roman emperors the ruler-effigies created in Egypt were made both in purely Greek or Roman as well as in traditional ancient-Egyptian style.

What this visual style of the conquerors looked like is illustrated very well by the *Ptolemy Cameo* (ill. left), whose picture vocabulary is completely within the Greek-Hellenistic tradition and reflects the customs at court. In the foreground Ptolemy II Philadelphus (283 – 246 BCE) is portrayed with an Attic helmet, whose neck-plate is decorated with a bearded head of Ammon. The cheek-plate is decorated with Zeus' thunderbolt; the snake is the Hellenized form of the Egyptian "uraeus" snake. Arsinoe II is in the background. She is the sister and wife of Ptolemy II. She too is represented with a royal head-dress. Ultimately, though, research is no more clear on whether the statue really depicts Alexander the Great or one of his successors, or whether the cameo shows Alexander the Great and his mother Olympias, in which case this gem would date more from the time of Emperor Augustus' reign (27 BCE – 14 CE), who thus would have programmatically seen himself as a successor of Alexander.

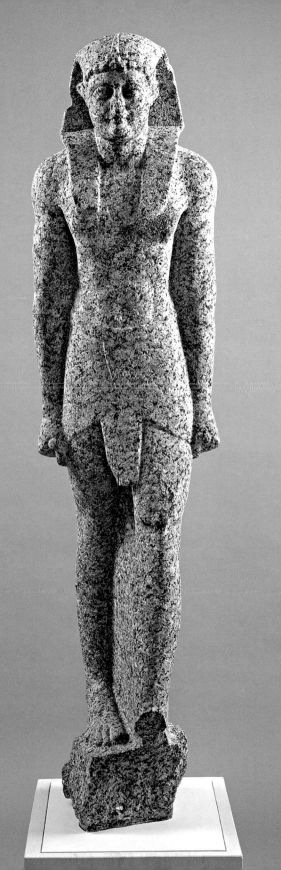

Alexander sarcophagus

Pentelicon marble, 1.95 x 1.60 x 3.18 m
Istanbul, Archaeology Museum

Even though Greek design ideals had often found their way into Oriental art before Alexander the Great, they only began to dominate after his campaign of conquest in the Mediterranean and the Near East. The *Alexander Sarcophagus* found in the royal necropolis in Phoenician Sidon, in modern Lebanon, is an outstanding example of the mixing of Greek artistry and Eastern art forms. This most magnificent representative of a group of sarcophagi for city kings, nobles and their wives was found in 1887. It was the last resting place of King Abdalonymos, who was put in power by Alexander the Great in 332 BCE and ruled for a good twenty years. All the sides and the two pediment triangles show relief representations portraying many figures. They are framed by richly decorated and powerfully moulded areas on the base and on the frames. The subject on the long sides is the battle between Macedonians and Persians as well as a joint hunt of lions, panthers and stags by Greeks and friends of the Macedonians dressed as Persians; these subjects are repeated on the short sides. The pediments show two further fight scenes. A horseman wearing a lion helmet who is fast approaching from the left is conspicuous in the large fight scene. He is stabbing a Persian with his lance. On the hunting frieze opposite a man without a helmet can be seen. He has a curly hair style and is wearing a royal band in his hair. He is attacking a lion that has locked his jaw into the neck of the horse of a hunting companion in Oriental dress. For a long time it was hoped one could recognize Alexander the Great in

Detail of the fight scene on the long side of the Alexander Sarcophagus

both figures as a victorious warrior and successful hunter. It is possible however that the man who commissioned the tomb has immortalized himself here.

Whether it is Alexander or Abdalonymos, the sarcophagus is a major product of Greek art during Alexander's time and a stroke of luck for research into polychromy. Even at its excavation the original colouring of the marble sarcophagus was unusually well preserved, with important and fascinating details. In addition the newest research has brought further details to light. The Greeks are depicted in idealized form, either naked or in armour and rider's cloak. Skin is indicated by light red-brown tones. The garments are shown in classical-elegant monochrome, the colours including gold-ochre and violet. In contrast the long trousers, skirted garments and cloaks partially covered in fur are richly decorated in the Oriental style. On the trousers diamond-shaped ornaments can be discerned, just as can be seen on the *Paris* from the Temple of Aphaea on Aegina (ill. p. 25). The cloak's inside lining is of another colour. Injured animals are bleeding from their wounds. The shields show miniature paintings in the most detailed execution. The representation of an audience scene on the inside of a Persian shield is fascinating. A servant is fanning air towards the king on the throne, while a bowing subject is approaching from the right. The representation is a faithful copy of a relief that was located in the Persian capital – the Greek artist must have evidently been quite familiar with the art of the Persian king's court. There must have been some detailed discussion between the client and the artist about the picture programme of a sarcophagus which weighs fifteen tonnes without its lid. Hunting, fighting, and banquet scenes were part of the conventional imagery in the funerary art of the ruling class, but in his sarcophagus Abdalonymos evidently valued the portrayal of scenes from his own life.

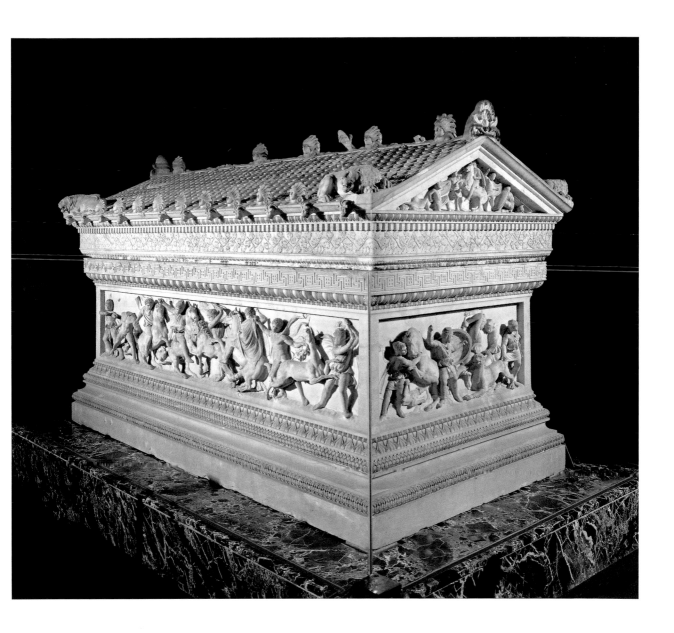

Boxer from the capitol

Bronze, height 1.28 m
Rome, Museo Nazionale Romano (Museo delle Terme)

===

Depictions of victorious athletes call to mind, for nearly every-one, the fit and steeled bodies and confident-superior facial expressions of the successful competitors, in short: images that correspond to our ideal of perfection and beauty. The views in the Greece of the 4th and 5th centuries BCE were not that far off from modern ideas. At that time the naturalistic representation of an athlete's body with the individual physiognomy of the victor was less important than the visual realization of the "kalokagathia", the specifically aristocratic ideal of perfect beauty and exemplary ethical attitude. Of course this attitude did not permit any representation of a successful athlete that showed him with cuts and other consequences of a hard fight; at most it was swollen and broken ears that provided a visual clue to the sport of boxing. Statues typically showed the victor as he was praying or sacrificing, or as he was putting on his victory band.

The cleaning of the body could also be a subject, but the scraping of sand and oil took place without noticeable effort. The bronze statue of a boxer discovered in Rome in 1885 brings across quite a different conception of a winner. He had evidently just won a difficult fight. He is sitting, bent forwards, and is supporting himself with his forearms on his long, open legs. His comparatively small head is jerked to the side and he is looking upwards. However, he is neither beaten nor crucially weakened, since the thighs have not caved in from the burden of the heavy body – there is still enough strength in his tensed muscles. A thick neck, broad shoulders, a strong chest, and a muscular back are all features of a physically fit body. The face shows signs of a heavy fight. The numerous bleeding wounds on the ears, cheeks, forehead, and nose are highlighted by shiny copper inserts, as are the lips, nipples, and the straps of the gloves. The broken and deformed nose may still be the consequence of an earlier fight, just like the already swollen ears. The eyes and teeth were inserted in another material. In contrast to the ordered curls of the beard, the moustache appears sticky with blood and sand. The body on the other hand is completely unharmed, which can be explained by the rules of Greek boxing, since they only allowed punches directed at the head, and not at the body. The boxer is wearing sharp-edged fist straps on his hands; these were wrapped over woollen or fur gloves. It is easy to imagine what kinds of injuries an opponent could sustain if hit with that kind of "boxing glove". Still, boxing was very popular and esteemed amongst the aristocracy as the toughest sporting discipline. One can already read the meticulous accounts of shattered cheeks, knocked out teeth, and lacerated faces in the "Iliad" and the "Odyssey", where the famous heroes fought each other thus. Anyone who walked through the Temple of Zeus in Olympia in the 3rd century BCE was able to admire victory statues from several centuries, from an archaic "kouros" via athletes in the classical-calm contrapost to such realistic portrayals as the boxer shown here. What a boxer really looked like after a victorious fight, not how he wanted to be seen – that was the artist's subject and the new interest of his contemporaries: the human being as an individual, not only beautiful and rich, but also ugly and vulnerable.

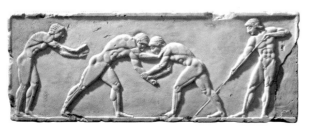

Wrestlers, 6th century BCE

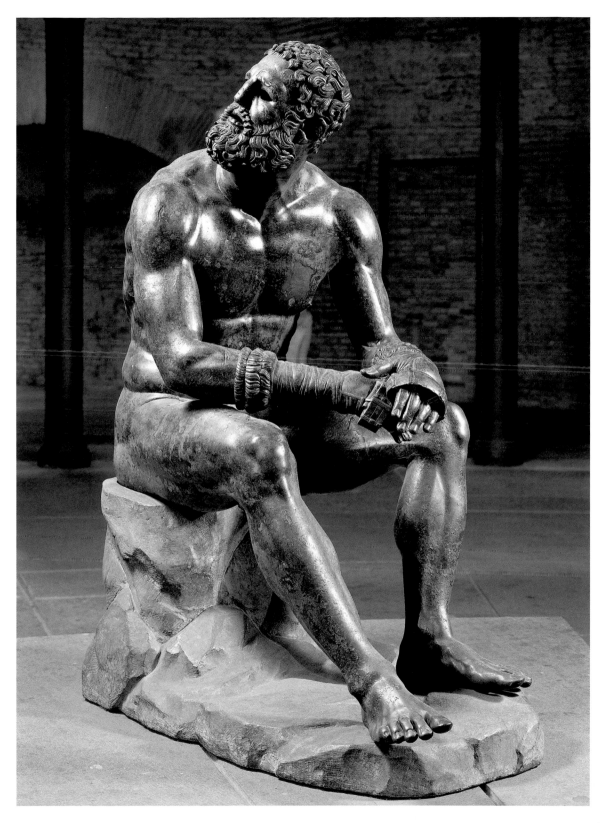

winged victory of samothrace

Marble, height 2.45 m
Paris, Musée du Louvre

Monuments erected to express gratitude for a victory amassed in Greek temples. They could be statues of athletes who had won the laurel or olive branch in Delphi or Olympia. So-called tropaia, constructions with weapons and armour the victor had won from his foe, also functioned as gifts of gratitude. Finally, the agonal principle also held sway amongst the many bellicose confrontations between the city states. Valuable objects from the spoils of war could be dedicated to a deity, as well as small and larger buildings, or artworks specially commissioned by the victor. They all of course had one thing in common: they were not just meant as thanks for the gods, they were also meant to impress visitors and increase the fame of their donors.

The victory goddess who became famous as the *Winged Victory of Samothrace* was a monument of a special kind for a triumph achieved in battle – and she was surely famous even before her discovery in the Sanctuary of the Great Gods on the island of Samothrace in 1863. The ensemble of Nike landing on a ship's bow is a prime example of how exact and subtle the planning of such a monument was, how attention was paid to a balance between nature and architecture, to lines of sight, to prospects, and to the presumed time an international audience lingered during its tour of the pan-Hellenic shrine. None of these finesses can be easily understood any longer, since the statue of *Nike* has been torn out of her original context and is now standing in a museum.

She was a gift of thanks by the Rhodians for their victories in the naval battles at Side and Myonessos in 191/90 BCE over the fleet of the powerful Seleucid ruler Antiochus III the Great (223 – 187 BCE). Its erection on Samothrace was in itself a blow against their enemy, because the island had previously belonged to Antiochus. The unknown sculptor created a real masterpiece, transforming a stone weighing many tons into a fast-flying goddess. The easily read symbol for victory was certainly a familiar motif, but in this case it was taken to extremes. Nike is wearing two gowns. Originally it was possible to tell them apart not just by the different structure of the materials but also

by the sculpture's colouring. A belt below the breasts is holding the thin undergarment under which one can see her navel – a sign of fast movement. Her cloak can be recognized by the wider pleats. The conceptual design of the figure forging forwards with diagonal axes at the front and side as well as the suggesting of a strong headwind lend the Nike an intensive sense of movement. At the same time she impressively combines standing and flying in one unsettled moment of balance. The Victory goddess is not approaching through the air like other Nikes. Instead she has just landed on the ship's bow and is trying to balance out the swaying in the wind with her body and wings. Thus she is not just bringing the news of victory, she is already proclaiming the achieved triumph. The sculptor has as it were abolished the high-classical contrapost, this balance of weight-bearing and non-weight-bearing, the epitome of calm and harmony. And thereby he achieved the embodiment of the emotionally laden moment after a victory, this outcry of relief, after all the tension, dissolves into ecstasy.

"only one single work of art" in the LOUVRE, "a sculpture, occupies an appropriate setting: the NIKE of samothrace, storming towards us from the first stairway landing, who appears as if she intends to mow down the hordes of visitors with imperial gestures."

Wolfgang Hildesheimer, 1988

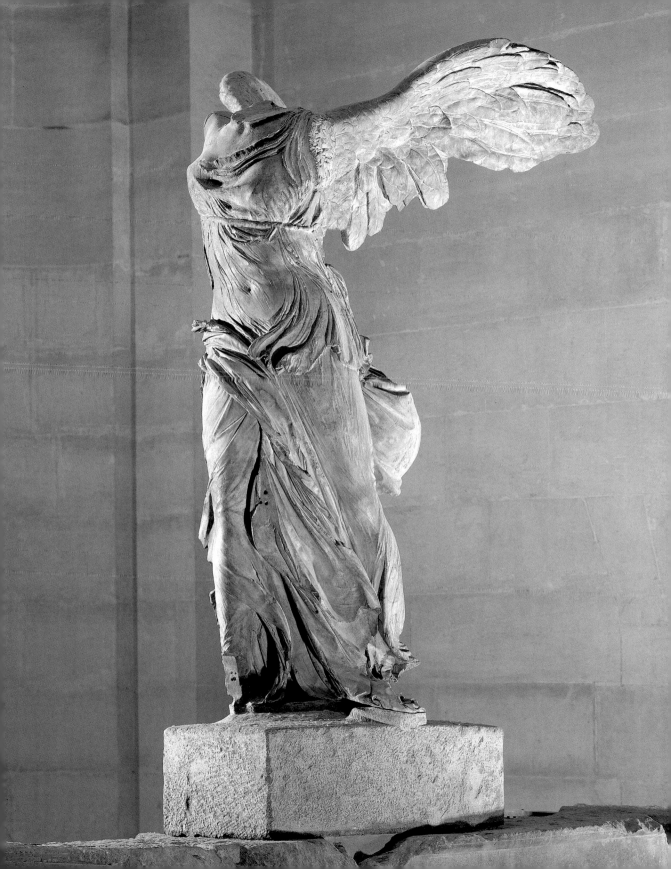

Athene and Alcyoneus on the Frieze of the Pergamon Altar

Marble, height of the frieze 2.30 m
Berlin, Staatliche Museen zu Berlin – Preussischer Kulturbesitz, Pergamonmuseum

This masterpiece of ancient sculpted art has an entire museum dedicated to it! Of course the Pergamon Museum in Berlin also houses other treasures. However, when one hears the name "Pergamon Museum" one immediately thinks of the massive altar with its magnificent relief representations of the battle between gods and giants. It was once located on the acropolis of Pergamon (in modern Turkey). Its surviving pieces were exhibited in Berlin after their excavation in the 19th century. After the approximately 160-metre-long *Parthenon frieze* the 120-metre long frieze of the *Pergamon Altar* is the longest and best-preserved high relief of Greek Antiquity. It was amongst the wonders of this world from early on, as the Roman Lucius Ampelius wrote in the 2nd century CE. "Pergamo ara marmorea magna, alta pedes quadraginta, cum maximis sculpturis; continet autem gigantomachiam." (In Pergamon there is a great marble altar, 40 feet high, with huge sculptures, it also has a gigantomachy).

The altar was surrounded by a hall of columns. A broad staircase led up to its sacrificial hearth. The altar also contained acroterion ornaments crowning the corners and a small frieze showing scenes from the life of the founding hero of the city of Pergamon – Telephus. The gigantomachy had been part of the repertoire of Greek art for a long time, as for example on the metopes of the Parthenon in Athens. In Pergamon, this Hellenistic centre of art, science, and literature the confrontation between gods and giants must have been a symbol of

The Pergamon Altar reconstructed in the Berlin Pergamon Museum

the victorious battles against outside enemies – battles that Pergamon had kept having to fight since the 3rd century BCE. However, there surely must have been a concrete occasion for its erection. This occasion must have been the victories of Eumenes II (197–159 BCE) over the Seleucids and the Galatai / Celts at the Battle of Magnesia in 190 BCE, enemies who had threatened the continued existence of Pergamon's territorial state.

It is surprising what the sculptors from Athens, Rhodes and other regions in Greece created in spite of having to subordinate themselves to a specified design. Whoever walked the length of the frieze would have seen a battle of the Olympian gods against the protesting giants such as had not been seen before: Zeus, Athene, Apollo, Poseidon and all the others are wrestling down bull-necked giants and hurling thunderbolts at them. The giants are defending themselves against their conquerors in impotent rage. The whole thing is one great scene of beating, stabbing and strangling – an anatomy of pain that still touches us today. On the "Athene plate" shown here, Zeus's daughter is effortlessly pulling the giant Alcyoneus up by his hair. His wide-open eyes, furrowed brow, and the tense spasm of the belly proclaim just one thing: agony and a very present fear of death. For he has lost the connection to his mother Gaia, Earth, who appears at the bottom right – and therefore he is vulnerable. Athene's sacred snake will kill Alcyoneus with one bite to the chest. The certain victory is brought by Nike approaching from the right. The wealth of detail and the breadth of variation of the entire composition have been admired time and again. No battle group resembles another, the same is true of the scales of the snakeskins, the working of the wing feathers, the gowns, sandals, or the hair styles – and still the sculptors managed to give the frieze a uniform look and thus created a unique masterpiece.

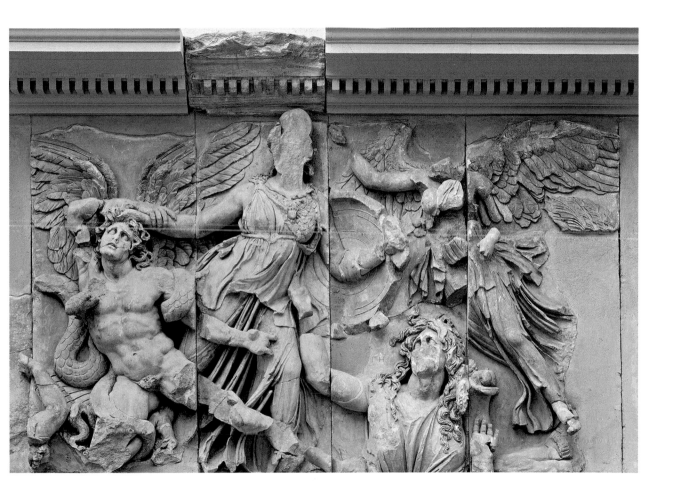

To stay informed about upcoming TASCHEN titles, please request our
magazine at www.taschen.com/magazine or write to TASCHEN America,
6671 Sunset Boulevard, Suite 1508, USA-Los Angeles, CA 90028,
contact-us@taschen.com, Fax: +1-323-463.4442. We will be happy
to send you a free copy of our magazine which is filled with information
about all of our books.

© 2007 TASCHEN GmbH
Hohenzollernring 53, D–50672 Köln
www.taschen.com

Project coordination: Juliane Steinbrecher, Cologne
Editing: Jürgen Schönwälder · Büro für Kunstpublikationen, Munich
Translation: Michael Scuffil, Leverkusen
Layout: text & typo, Anja Dengler, Munich
Production: Ute Wachendorf, Cologne
Design: Sensnet

Printed in Germany
ISBN: 978-3-8228-5450-1

Page 1

**Achilles kills the Amazon queen
Penthesilea, so-called Penthesilea bowl**
c. 455 BCE, clay, diameter 43 cm
Munich, Staatliche Antikensammlungen
und Glyptothek

Page 2

Venus de Milo
mid 2nd century BCE
marble, height 2.04 m
Paris, Musée du Louvre

Page 4

Funerary Stele of Hegeso
end of the 5th century BCE,
marble, height 1.49 m
Athens, National Archaeological Museum